Professional Secrets of

NATURAL LIGHT PORTRAIT PHOTOGRAPHY

Douglas Allen Box

AMHERST MEDIA, INC. ■ BUFFALO, NY

Published by:
Amherst Media, Inc.
P.O. Box 586
Buffalo, N.Y. 14226
Fax: 716-874-4508

Publisher: Craig Alesse
Senior Editor/Production Manager: Michelle Perkins
Assistant Editor: Barbara A. Lynch-Johnt

ISBN-13: 978-1-58428-045-3
Library of Congress Card Catalog Number: 00-132623

Printed in Korea.
10 9 8 7 6 5 4 3 2 1

Table of Contents

About the Author:

Doug Allen Box, M. Photog. Cr., CPP, has spent years inspiring photographers of all levels to go beyond the normal studio into a more successful and creative business. **Besides being an excellent photographer, he is a dynamic and entertaining speaker** and has appeared in seminars

and conventions across the U.S., Canada and Mexico. He was also chosen by Hasselblad University to teach at their International Wedding Institute in 1998, 1999 and 2000. His fun and genuine style of teaching will help you learn to be a better photographer. His articles and images have graced the pages of most professional photographic publications. He is the author of *The Photographic Success Newsletter* and has written several books including *Professional Secrets for Photographing Children* and *Professional Secrets of Wedding Photography*, both published by Amherst Media, Inc.

Introduction

Photography literally means light writing—photo (light) and graphing (writing). As with any kind of writing, success relies on your ability to control the medium. This book will talk a lot about finding the light we need to make beautiful images and controlling the light we find when it is not the way want it.

○ QUALITIES OF LIGHT

Photography began with natural light, so our discussion will concentrate mostly on natural light. Light has several qualities. The ones we will be concentrating on are quality, direction, intensity and color.

Quality: For most portraits, direct sunlight is not the most flattering light. It is hard and contrasty and can cause people to squint. The most flattering light for portrait photography is sunlight reflected off the sky. The first and last hour of the day typically provide the most flattering light. You can find good light in open shade. Working under a tree, on a porch, or near a window can also provide quality light for portraits.

Direction: If you stand at the subject and look toward the camera you should see an area of open sky on one side or the other. For the

(Above and Opposite) Successful photography begins with learning about light's qualities, and how to control them.

most part, light should not come from above. This "top light" can cause shadows from the eyebrows on the eyes.

Intensity: Sunlight is hard light, it causes a hard line between the light and shadow area. Light from an open sky is considered soft, and you will see a soft line between the light and shadow areas of the subject's face.

Color: One problem many people have with natural light photogra-

phy is that they photograph people in an area where there is no open sky. Without the sky illuminating the subject (illumination from the sky is really sunlight reflecting off the sky) the color of the light is contaminated as the light bounces off leaves, buildings and other objects. This can yield unflattering results in your portraits.

○ DEVELOPING YOUR EYE

Do you have passion for photography? How badly do you want to create great portrait photography?

As you'll soon see, it only takes a little extra time to transform your photographs from "just okay" to something really special—images that will be treasured for years.

Why are you taking this photograph? Most portrait photographers take pictures to preserve memories. What can you do to make that memory better? More vivid? More lasting? What can you do to make the photograph more pleasing to look at? What can you do to make the image recreate the moment when you view this photo days or years from now? This is what we will cover in the following pages.

○ SIMPLICITY

Remember, simplicity is visually stronger than complexity. You are telling a story with your photographs, but you don't have to tell the whole story in one photograph. *See*, don't just *look*!

Will it take some time? Will it take some studying and practice? Of course—anything worth doing requires some effort. Will it be worth the effort? I believe it will. Whether you are a professional who wants to improve your craft, or a mom who just wants to take better vacation photographs, you can benefit from the information in this book.

For 29 years, I have worked continuously to improve the photographs I have taken. I have studied and practiced to perfect my craft. I have yet to take the perfect photograph. There is always something that could be better in every image. Some of the things are out of my control when the image is made, due to the lighting conditions or placement of objects in the scene. Unlike a painter, I cannot choose to omit or change objects. I must deal with reality. Can we improve on what is there? Yes! We have a number of controls at our fingertips.

The first step is learning to see with a photographic eye. You must force your mind to see the way a camera sees, and to look at the light the way film sees light. One of the hardest skills to learn is to force yourself not to look *through* the viewfinder, but to see *what is in* the viewfinder—to make your eye scan the entire scene the camera sees.

Your brain will trick your eye. If you simply look through the eyepiece of the camera, your mind acts as a telephoto lens, disregarding the clutter in the foreground, missing the distraction behind the subject and directing your attention to the subject alone. Unfortunately, cameras have no minds and see all the things you can allow yourself to overlook. As a result, you must do the thinking for your camera. You must see the full view that the camera will record and determine if you must move closer to bypass the clutter in the foreground. You must see the distractions behind the subject and change your lens or angle of view to remove them.

Adopt the habit of making your eye look all around the view finder, then pause and see everything the camera sees. Then, decide if the scene is to your liking. By doing this, you can instantly improve the quality of your photographs.

○ ADDITIONAL TOPICS

In addition to exploring the qualities of light and looking at ways to improve your photographic vision, we will also discuss:

- Finding good light, controlling light that is not that way we want it, and how to tell the difference
- Film—when to use a particular film and why
- Which lenses to use in each situation you encounter
- Measuring light
- When to add light
- Posing—letting natural posing happen, and posing to make it look natural
- Arranging elements in the image—and excluding some
- Creative expression

By mastering the mechanical elements of photography, you can free yourself to fully explore photography as an expression of your creative vision. Achieving these goals for natural light portrait photography is the subject of this book.

Natural Light Basics

As with many photographers, I began my career in photography using natural light. It was clumsy at first, with hit-and-miss results.

Learning to see the light is the first step. Whether you use window light, porch light or overhead light, look carefully at the face of your subject and see the way the light shapes it. Watch the way it wraps around and touches each feature. Look for light that illuminates one side of the face while just kissing the cheek of the other. Turn the face until the eyes are out of shadow and sparkling with catchlights.

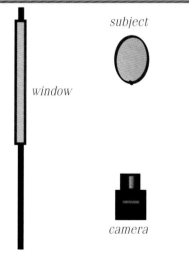

subject

window

camera

For simple window lighting, place the camera perpendicular to the window. Then turn the subject slightly toward the window until catchlights appear in both eyes.

◉ WINDOW LIGHT

To learn to control natural light, start with window light. Window light is a good teaching tool, since it is easier to see and control than open skylight. The goal should be to find directional light (light that comes strongly from one side), since this provides flattering shaping of the subject's face. In this respect, using window light is very much like using a soft box in the studio—except you move the subject to the light, rather than moving the light to the subject.

Getting Started. Pick a window that does not have direct sunlight coming through it, but from which you can see blue sky. A window on the north side of a building is almost always a good choice, but a west-facing opening in the morning or an east-facing one in the afternoon will also work well.

Begin by placing the camera perpendicular to the window, with the subject positioned in between the camera and the window. Then, turn the subject's face toward the

window. Watch the light in the eyes. You should see the reflection of the window in both eyes. You should also have an area of illumination on the cheek that is farthest from the window. Stay close to the subject. The closer you are to the subject, the easier it will be to see the exact effect of the light.

Controlling Contrast. The second step in controlling the image is controlling the contrast. Unless it is modified, the basic contrast is contingent on the dynamics of the room. The more additional light in the room (reflected light from white walls, light from an open door, etc.) the less active lighting control you will need. Contrast can also be controlled by changing the distance of the subject from the window—closer for more contrast, father for less. You, as the artist, must decide how much contrast you want for each subject.

You can also bring in a reflector to lower contrast. A good starting point is to place the reflector the same distance from the subject as the subject is from the window. Keep the reflector slightly in front

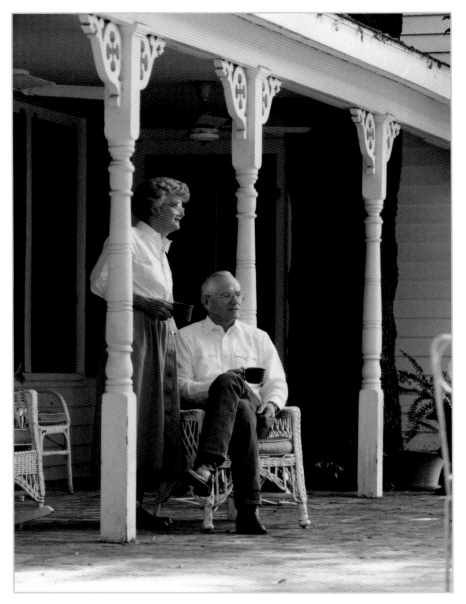

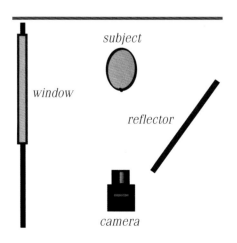

of the subject. The goal is to bring in light from the front so that it wraps all around the face.

⊙ PORCH LIGHT
Now that you have learned to control the light at a window and, more importantly, learned to see the light, you are ready for the next step in this journey of mastering natural light. The porch is the next area we will explore. Imagine that the light hitting the porch is the light coming through

a very large window. What makes porches a great place for photography is that the main part of the light comes from one direction (again, much like with a window). The building blocks the light from one side, keeping it from being flat light (light that illuminates both sides of the face equally). The roof of the porch blocks the light coming from the top, eliminating possible problems with light from too high an angle. When we move outdoors, you will especially appreci-

ate the natural light blockers available on a porch.

Getting Started. When using a porch, the axis of the camera should generally be positioned to run the length of the porch, with open sky on one side of the camera and the building on the other.

Controlling Contrast. The intensity of the light, as well as its contrast, can be controlled by subject placement. The closer the subject is to the edge of the porch, the more intense the light and the more contrast (again, also true for window light). Usually you don't need a lot of additional reflected light on a porch. The one thing you need to concentrate on is seeing the light. If you can't *see* the light, you can't control it.

○ OUTDOORS
Outside, seeing the light is more difficult due to the overall amount of ambient light. Light is bouncing all around—coming from all directions. Your job is to find a good clean source of "reflected" light, sunlight reflected off of the sky. This light source should be fairly broad and close to the horizon. I like to work in

open shade with the sun near the horizon (early morning or late afternoon).

Finding Good Light. To find good light, look for an open area of sky through the trees. To do this, stand where the subject will be and look towards the camera. You

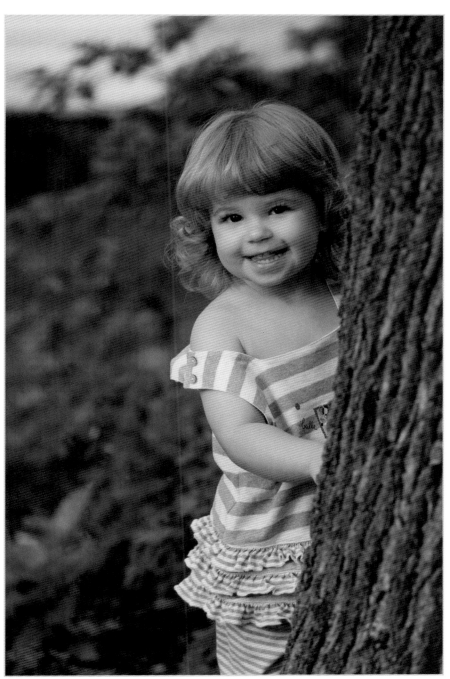
Open shade provides soft, beautiful lighting for portrait photography.

should see a fairly large patch of open sky on one side. If that patch of open sky is directly behind the camera, the light will seem flat and won't produce roundness in the face. Think of the open sky as a big window. To achieve directional lighting, the open sky should be in the same relative

position as the window was (or the opening of the porch). I usually work on the edge of the tree line where skylight, not sunlight, falls on the subject from a relatively low angle and from one direction.

Here's a good exercise to help you "see the light." Find a patch of open sky, and place your subject in the area you think will be the right place, then walk around the subject. On one pass around, have the subject look where the camera will be. On the second pass, have the subject turn to follow you around. As you walk around, look at the way the light falls on the subject's face and determine the best position. The closer you are to the subject, the easier it will be to see the light.

Another trick I have for finding a good light source outside is to look at the trunks of trees. **You should be able to see a dark and a light side to the trunk.** The tree will look "rounder" in this light, and the rounding will also look good on your subject.

⊙ OVERHEAD LIGHT

One of the major problems with photographing outdoors is light coming from overhead. This is something you do not have to control with window light or porch light, which comes from the side. The problem with overhead light is that it forms shadows in the eye sockets, creating what I call "raccoon eyes." Outdoors, you have two choices: find a place where branches block the overhead light

Avoiding distracting elements in the background will greatly improve your natural light portraiture.

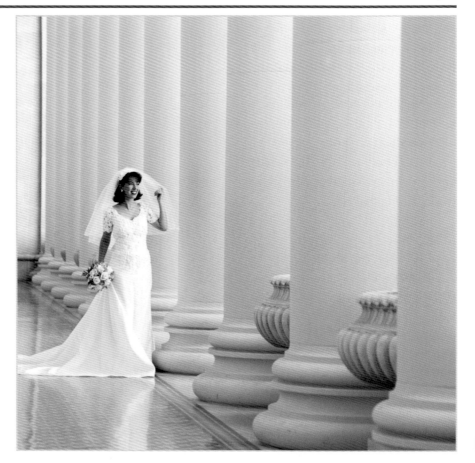

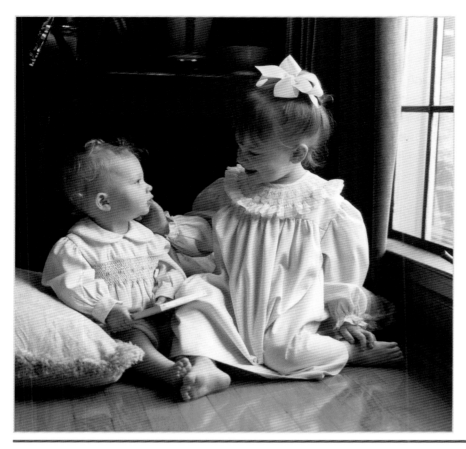

Simple, non-distracting patterns and styles will ensure that the subject's clothes don't do battle with the carefully evaluated lighting.

from hitting your subject, or you can use a flat black light panel to block this light from overhead.

If you decide to use a panel, start by aligning the back edge of the panel (which functions basically like an umbrella) near the middle of the subject's head. This will let a little of the overhead light hit the top of the subject's head—creating a natural hair light.

○ BACKGROUNDS

With all natural light photography (but especially outdoor photography where the environment is more complex and harder to change), you have to also be concerned with the background. It is important to avoid distracting hot (bright) spots from direct sun, too many bright colors or objects,

bright areas in the sky, or other confusing backgrounds.

Two things will help you control your background: a large aperture, and a long focal length lens. By making the exposure with your lens set at its widest aperture, your depth of field will be minimized. **This will help to separate your subject from the background** by reducing the background sharpness. Using a long focal length lens (150mm or longer on medium format) accomplishes two things. First, the longer the focal length, the narrower the depth of field you will achieve. Second, the long focal length has a narrower field of view, eliminating much of the background. This comes in handy when you can only find a small area of background that is

suitable. I use a 250mm lens on my Hasselblad 503CW for most of my outdoor portraits—even small groups. This is a wonderful lens for these natural light images.

○ TRIPOD/CABLE RELEASE

When using a long focal length lens at slow shutter speeds, always use a tripod and a cable release to avoid loss of sharpness from camera movement.

○ TIME OF DAY

There is one thing that will make your job easier—shooting at the right time of day. In my opinion, the best time of the day to do outdoor portraiture is from about an hour before sunset, up to several minutes after the sun completely sets. The first hour of the day, is also great, but I usually have problems finding people willing to get up, get dressed and be ready by that first hour. So, for me the "sweet light" time is that last hour of daylight. The light is softer and has less contrast. You will also have less trouble with hot spots in the background, since there is no direct sunlight.

Of course, time of day is not as important if you are doing window or porch lighting situations. In these situations, just use the light coming in a direction opposite from the sun.

○ METERING

The next important skill you must master for great natural light is proper metering. I use the flat disk on the Sekonic L-508 meter. For the way I meter and the way I photograph (both of which make a difference in the way you rate the film) I rate the Kodak Portra film at the suggested ISO. I place the meter close to the subject's face with the flat disk pointing straight at the camera lens. You will see that with the flat disk, turning the meter left or right off the camera axis will vary the meter reading. Always test a new film or new metering technique before trying it out on a client. Work with your lab, ask them what exposure numbers they like for your specific film. Constantly monitor these numbers to make sure you have good exposure for your negatives.

○ CLOTHING

The last thing I want to touch on that will make your natural light photographs—or any photographs, for that matter—much better is clothing. Clothing, although having nothing to do with lighting, is the last component to great photography. I have had wonderful subjects, great locations and perfect lighting conditions ruined by bad clothing. Simple, non-distracting colors and patterns seem to photograph best. This is of course a huge generalization, but is a good rule of thumb to begin with. It is especially true when photographing groups.

○ IN CONCLUSION

Natural light can be the most beautiful light you use for photography. It has a special quality. But you must learn to use it. You must learn to see the light. Work with it.

There is light that can whisper.
There is light that can shout.
You cannot rush the light.
Wait for the moment,
Wait, wait for the light...

Natural Light Portrait Basics

○ THE LIGHT FINDER

It sometimes takes years to learn how to find perfect, directional light outdoors. But a friend, Dennis Wells, showed me a gadget he made to aid photographers in finding great light. It also helps you determine if the lighting situation is too contrasty for a flattering portrait.

The simple but effective tool he showed me is a small wooden block with two different shades of photographic paper on adjoining sides. I took his design and made subtle changes (I used two different shades of gray paint to make it more durable), but the concept is the same. I call it the Light Finder. This device can take years off the learning curve of natural light photography. The Light Finder works with any continuous light, but is especially useful for outdoor, window and even incandescent light.

Using the Light Finder. Whether you are using the Light Finder outdoors, with window light or with porch light, the technique is the same. Turn one of the darker sides toward the light source, with the corner facing you. Then, move around while holding the Light Finder at eye level. Stop when the

two sides look approximately the same shade. You have found good light with approximately a 3:1 lighting ratio. Remember, the two sides don't have to look exactly the same. After all, you will not always be in an area that has exactly a 3:1 ratio. **There are times when you must settle for a smaller ratio.** In this instance, you will only see a slight change in the two sides of the block. Then you will have to make a decision as to whether all the other good qualities in this spot outweigh the lack of perfect light. If they do, then use it.

The Light Finder will also help you determine if the lighting situation is too high in contrast. If you turn the dark side of the Light Finder

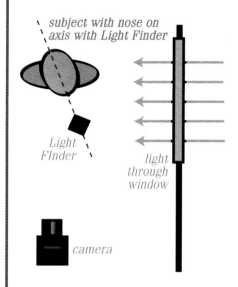

subject with nose on axis with Light Finder

Light FInder

light through window

camera

Point the subject's nose in the same direction the corner of the Light Finder is pointed when the two sides appear to be the same shade. (The darker side of the Light Finder is pointed toward the window.)

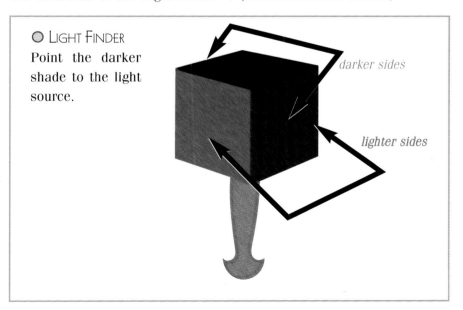

○ LIGHT FINDER
Point the darker shade to the light source.

darker sides

lighter sides

toward the light source and it appears brighter than the light gray side, then the contrast level is more than 3:1. In this case, you will probably want to use a reflector to add light to the subject. Place it opposite the light source.

How to Make a Light Finder. You can make your own light finder! Here's how. Take this book to a local paint store and purchase two very small cans of paint in the shades of gray shown below (or

make a color photocopy of this page, cut out the squares and affix them with spray glue). Make a wood block (or buy one at a hobby/craft store) that measures 1"x1"x1". Then, attach a handle on one side. This will become the bottom. (To make a "professional" model, paint the handle, top and bottom black!) Paint two sides (opposite of each other) with the darker shade of gray, and the other two sides the lighter shade.

○ KEEP YOUR CAMERA READY
Spontaneous moments make priceless pictures. How many once-in-a-lifetime pictures have you missed because you didn't have a camera with you? It's easy to avoid that frustration by keeping a camera handy.

If your regular camera is too large to carry conveniently, consider a low-cost pocket-sized model as a

standby. When I first began taking photographs, most 35mm cameras came with a case. They were called an Ever-Ready case. I guess this was because it provided some protection without having to store the camera in a camera bag. The theory was that this was quicker than retrieving your camera from the bag to make an exposure. Even though these cases opened fairly easily, I always dubbed my case a "Never-Ready," because, regardless of how easy they were to open, by the time I opened the case, turned on the camera,

brought the camera to my eye and focused the lens, any fast action or fleeting moment was gone.

When photographing a wedding, I keep the camera on, and preset the focus to about ten feet (or whatever seems to be the likely distance at which any action will happen). I predetermine what the exposure will be, and stay ready for something exciting to happen. Many times I will see something fun happening and can step into place and make the exposure—many times without even bringing

Whether on vacation or shooting a wedding, keep your camera ready for the opportunity to capture a once-in-a-lifetime shot.

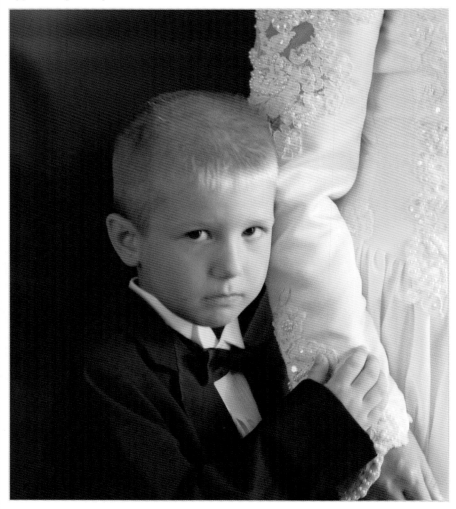

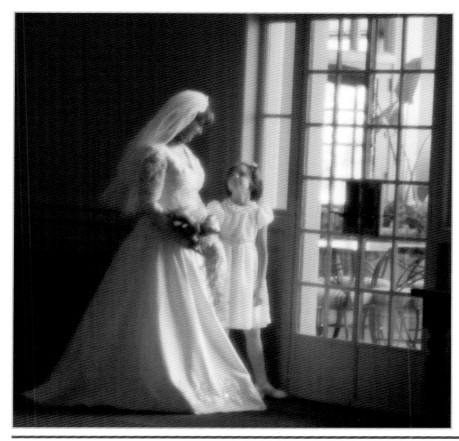

Placing the bride and little girl against the wall instead of the window created a more simple background that keeps the attention on them.

the camera to my eye! I like to call it shooting from the hip.

This is especially effective when using a wide-angle lens. These lenses have a tremendous depth of field, and a large angle of coverage. I know that if I'm close to the focus point (six to twenty feet) and aiming the camera in the general direction, I will probably get something. After I make this "from the hip" shot (if time permits), I focus and compose the image correctly. This way, I know I have at least *something* of the once-in-a-lifetime event. **I do the same thing when on vacation with my children—I stay ready.** That expression may only last a moment!

This works best with the camera in manual focus mode, since with autofocus, the autofocus indicator must be pointed right at the subject for the camera to focus correctly. If it misses the subject and focuses on the background, you may not have an acceptably focused image.

○ Keep People Busy

When photographing people, I like to keep them busy! This helps create pictures with a feeling of lively spontaneity. Let the subjects react with what is around them—especially if it is another person. To avoid stiff, static poses, encourage your subjects to be active. They will look more relaxed.

○ Use a Simple Background

The use of a simple background focuses attention on the subject and makes clear, strong pictures.

Good lighting can make your photographs more interesting, colorful, dimensional and flattering to the subject.

○ LOOK FOR GOOD LIGHTING

Adequate lighting is essential to expose film, but good lighting can make your pictures more interesting, colorful, dimensional, and flattering to the subject. In the image to the left, there is a large patch of open sky directly in front of the two children. In most cases, you need open sky to give you good clean light on your subjects. I placed the hair of the young lady directly behind the profile of the young man. This kept his face from blending in with the fence and not being as strong.

○ ELIMINATE CAMERA MOTION

Great photographs are sometimes missed just because the photographer didn't hold the camera steady. When you push the shutter button, press it gently—or use a shutter release (cable release). You can also steady the camera by bracing it against something firm, or use the camera's selftimer. If possible, use a tripod.

○ INCLUDE THE BACKGROUND

If the background helps tell the story, include it. While getting close can help to eliminate distracting and/or unnecessary backgrounds, showing the setting can make the photograph more interesting and tell a better story. Think of a bride ascending the steps of a church—showing the church in the background adds significantly to the image.

Again, you should be very careful to avoid including bright colors in the background, or distracting hot spots.

○ PLACE THE SUBJECT OFF CENTER

There is nothing wrong with placing the subject in the center of your photograph. However, placing the subject off center can make the composition even more dynamic and interesting.

○ MAKE IT PERSONAL

Try including personal props in the photograph. Elements in the foreground add a sense of distance, depth and dimension. They also make the photograph more personal.

Techniques and Images

Having explored the fundamental techniques of outstanding natural light photography, we will now look at these techniques in practice. In the following section, photographs are paired with a discussion of all the techniques that went into creating the individual images.

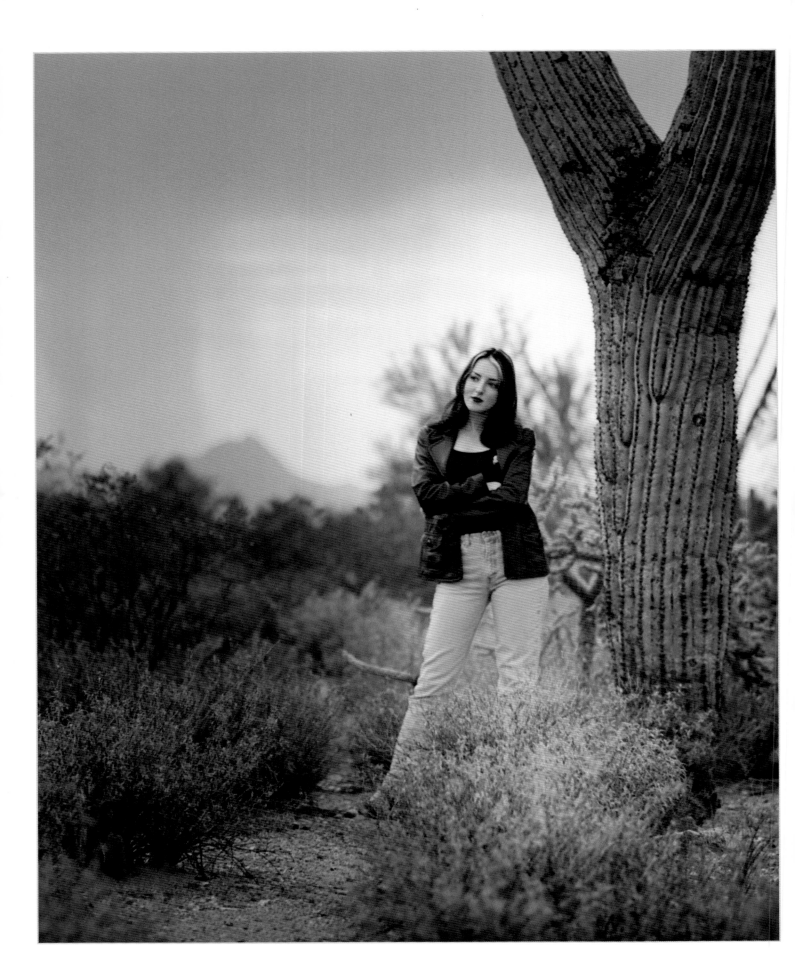

Combating Flat Lighting

While teaching a class for Hasselblad University's International Wedding Institute in Tucson, AZ, the class went out into the desert for a session with some hands-on demonstration. For the shoot, **I wanted to create a natural-looking photograph that reflected the young lady's attitude.**

○ POSE
For most people, putting their weight on one leg while extending the other leg or bending the knee creates a comfortable pose. It also gives the body a natural flow and usually drops one shoulder a little. By having the model tilt her head to the low shoulder we created an S-curve with her body. The S starts with her right leg, then moves through her hips and torso. Her tilted head completes the S-curve. This is a very attractive and feminine pose for women.

Although this model is certainly very feminine, she also had a confident attitude. Her crossed arms and the straight-on pose creates a dichotomy with the feminine flow of her body. It's a perfect pose for this beautiful woman.

○ PROP
The prop is the cactus. She certainly couldn't lean on it, but the cactus adds a sense of strength to the image. This also reinforces the overall strength and confidence of the woman and the pose.

○ BACKGROUND
Just as we arrived I noticed a storm brewing. I found a spot that featured a very vertical cactus to mirror the column of rain coming from the cloud. I then chose a camera position that placed the three vertical objects (cactus, subject and rain) in a row. I felt that placing the objects in the frame without symmetry (unequal distance between the three) gave a stronger feeling to the subjects. I also chose a camera height and left-right orientation that placed a tree directly behind the subject to break up the large white area of the sky. I knew that the 250mm lens would cause it to go out of focus and keep the branches from being a distraction.

○ LIGHT
The light was quite flat coming from the open sky all around. The sun was behind a cloud and did not provide much direction to the light. Placing the model near the cactus helped this, since it functioned as a light block. It blocked some of the light from hitting one side of the subject, creating a directional light effect on the face.

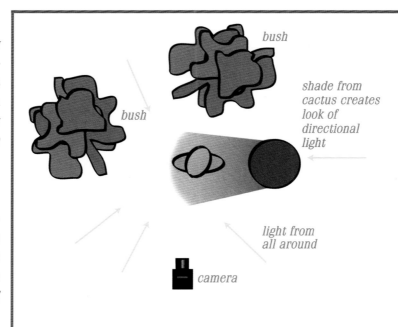

bush

bush

shade from cactus creates look of directional light

light from all around

camera

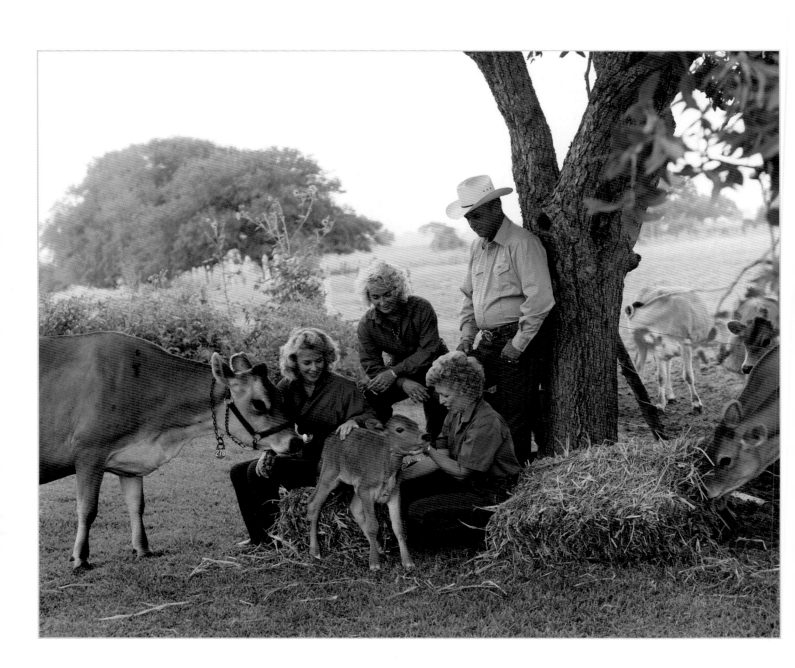

Interaction

One of the first decisions you will have to make when photographing families is whether you want the subjects to be involved with the camera (looking at the camera), involved with the environment or involved with each other. Neither one of these styles is right or wrong—just different. In this example, I chose to have the family involved with each other.

Posing

When posing a group, you want to make sure each person looks good in their own, individual pose. Then, bring each person together into the group. **I also try not to have two heads at the same height.** By having each person's head on a different level, you give each person his or her space in the photograph and importance in the image. This also gives a sense of motion to the image and keeps the image from seeming stagnant.

Props

These show cows are almost like family to this wonderful family. I personally enjoy images like this, where the subjects are doing something besides looking at the camera. It adds interest to the photograph. Another prop that keeps your interest in the photograph is the clothing. Matching outfits keeps the image simple and uncluttered. The dad even seems to match the calf!

Lighting and Photography

I met the family shortly after sunrise to take advantage of the

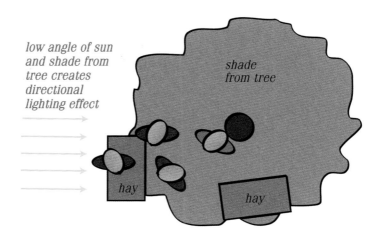

low angle of sun and shade from tree creates directional lighting effect

shade from tree

hay

hay

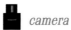 *camera*

morning light, which is softer than when the sun is higher in the sky. It also comes from the side, giving it direction. It is not as bright as it is later in the day, and therefore does not cause as many problems with hot spots in the background. For the shot, I used a 150mm lens on a Hasselblad camera. I did not own a 250mm lens at the time, but if I had used one the sky would not have been as prominent.

Early Morning Light

Clothing Selection

Wow, this is a big family! Notice how each face seams to be on a different level, giving everyone their space in the frame. Notice, also, how the individual families are posed together within the larger group.

○ POSING

What makes this image noteworthy is the clothing. The family members all look like they belong together. Try to imagine what this portrait would look like if everyone were in a different color outfit.

While I was making this image, another photographer happened by, "How do you get everyone to dress alike?" he asked. **It's called respect, I told him.** The great coordination is due to the fact that I talked to the family and told them the importance of wearing the proper clothing—and told them *why*. I told them that the portrait would look better and stressed how important the clothing is to making the image great. Because they respected me as a professional, they made the effort to dress everyone alike. I think it looks nice and is well worth the effort.

○ LIGHTING

The lighting in this image is fairly flat. If you look closely, you can see that the light coming from camera left is slightly brighter than the light from camera right. I used the light finder (shown on page 13–14) to determine where the brighter light was, then pointed the family's bodies and faces toward it.

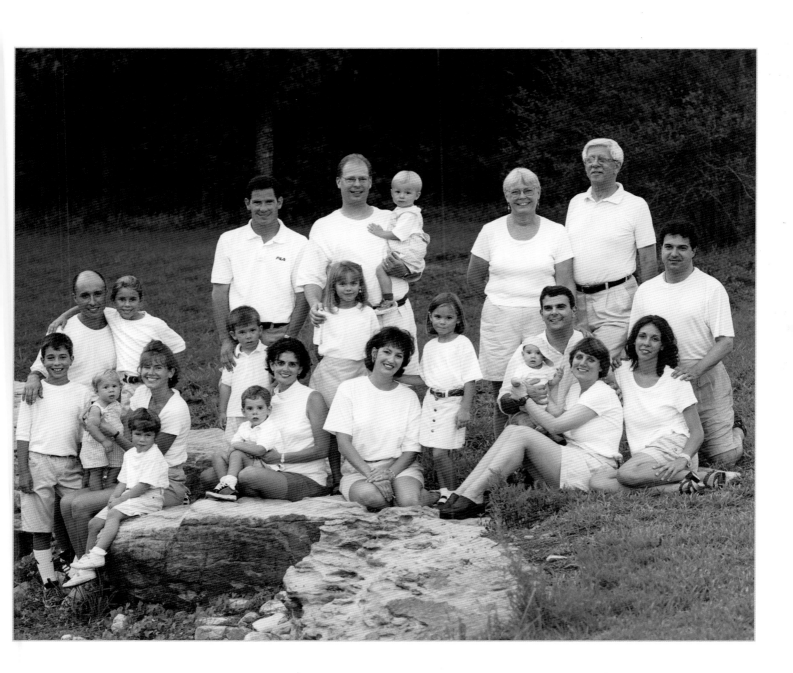

Adding Flash

I did several posings with this family. Being a fellow photographer and a great friend, **the husband and I worked together on choosing where along this river we wanted to photograph** their portraits. We found three different places for the group, and determined that the best time for the session would be late afternoon.

● LOCATION AND POSING

In the first series of photographs, we posed the family in the middle of the river with everyone standing. We made several exposures, then moved to an area along the bank. I seated the subjects on the irregular rocks, placing each person's head on a different level. This gave each person their own importance and space. Then we moved to the final posing area where we did two different groupings at this last place.

● PROPS

Of course we can't move the rocks, but we can move the people around on the rocks for a great pose. The other prop is the clothing—look how nice the matched clothing looks in this image. Imagine how different the effect

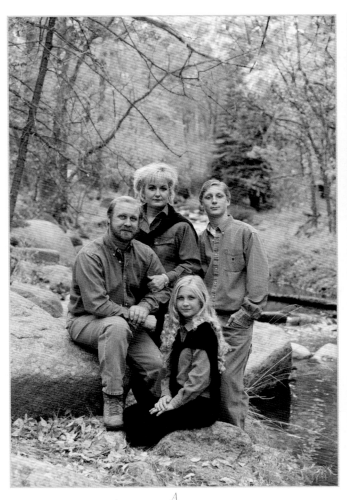

A

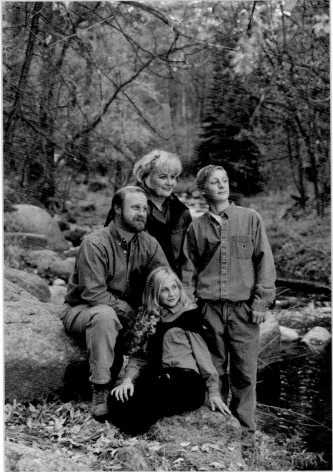

B

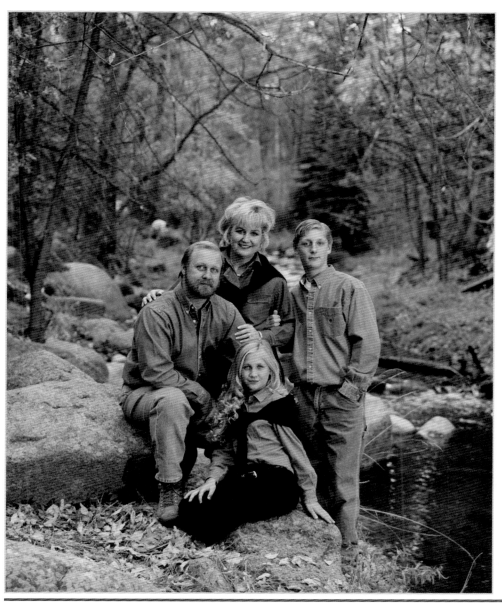

would be if everyone in the photograph wore a different color or pattern!

PHOTOGRAPHY

As we have learned, finding an area with open sky off to one side is useful for producing beautiful images with directional light. At this particular place, there was no open sky to the side because of all the trees. The only open sky was directly above.

METERING

Because of this, natural light needed a little help. Look at photograph A (opposite page), and notice the flatness of the light and the dark circles under the subjects' eyes. To eliminate this, I positioned a flash across the river at approximately a 45° angle to the faces. To trigger the flash, I used a radio slave (the receiver was attached to the flash, and the transmitter was attached to the

camera). This eliminated the need for a cord between the flash and the camera.

I determined the overall ambient lighting to be 1/60 second at F/8. Therefore, I metered the flash and adjusted it to give an output of F/8. I set the camera to 1/60 second at F/8. **Look at the difference adding the flash made** (photograph B). With it, I was able to add direction to the light.

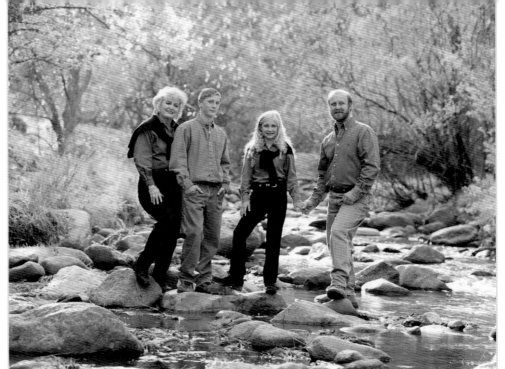

A (right)
B (below)

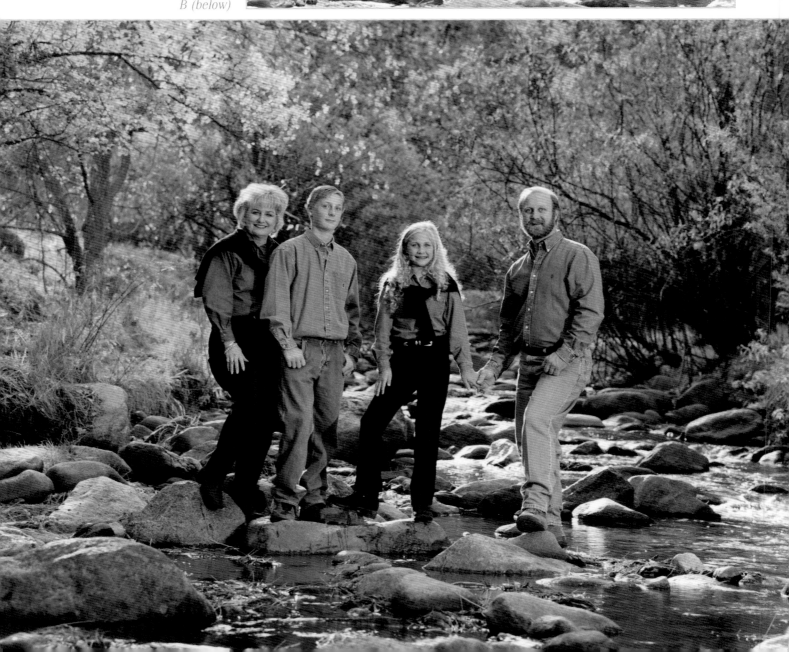

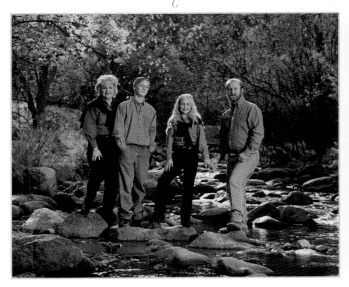

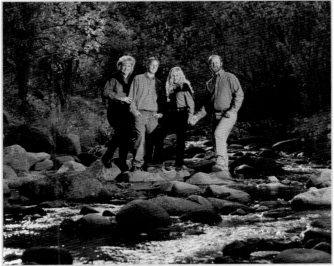

Control of Added Flash

Let's look at the control we can have using the technique of adding an off-camera flash outdoors. In the first image (photograph A, opposite page), the scene was photographed just as it was, with light from the top. I metered the situation normally by placing the meter (in incident mode) at the subject. The reading was F/8 at 1/60 second. In the second image,

I added one light, with an output of F/8.5. I set the camera for F/8.5 at 1/60 second. Notice that the background recorded darker, and that the light now has direction.

⦾ BACKGROUND TONE

In photograph C (above), I used the shutter speed to darken the background. When using flash and ambient light together, I think of the flash as being controlled by the F-stop, and the ambient light as being controlled and contoured by the shutter speed in relation-

ship to the F-stop. Essentially, you have two photographs in one: the subjects are illuminated by the flash, and the background is lit by ambient light.

In photograph C, I increased the shutter speed from 1/60 second to 1/125 second, but left the aperture at F/8.5. This kept the same amount of flash illumination on the subject. But, because I decreased the amount of light recorded from it, the background looks darker.

In the last photograph (photograph D), I increased the shutter speed by one more stop—to 1/250 second. This made the background darker still.

⦾ ARTISTIC CHOICE

Which do you like better? I like photograph B the best. You, as the artist, get to decide which you like best. Had more direct sunlight been shining on the background in photograph D, it might have been the best.

Elements of Great Photography

On the opposite page is my favorite image of the session. It shows enough of the environment to tell the story of where the family was. **It also includes enough space around the family to make this a great candidate for a wall portrait.** It has all of the elements of great photography:

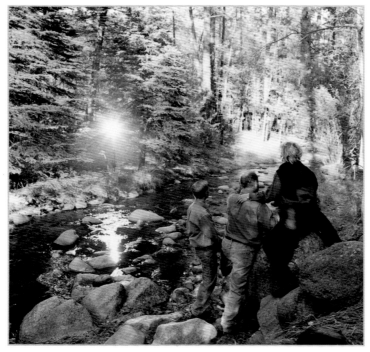

In this "from the back" photo, you can see the placement across the river of the flash that provides the directional light. Notice the camera on the far right side of the photograph.

- **Great Clothing.** The clothing matches and the outfits look good together. This is the result of doing a good job planning the photograph and emphasizing the importance of matching clothes. It allows the viewer to enjoy the photograph without looking at the clothing or having it detract from the subjects. Great job, Mom!

- **Great Location.** What makes a great location? Beautiful colors, no distracting elements, and even lighting. It's also great if the location adds to the story of the photograph. This photograph was taken at a stream that is just down the road from the family's vacation home. They have lots of great memories from this spot, which makes the photograph even more special.

- **Great Lighting.** It wasn't great naturally. Fortunately, we were able to add an off-camera flash to create great lighting, with direction and the proper color temperature. Often, when there is no open sky, the light in the area is bounced off leaves or other objects. This gives the light an off-color and muddy look.

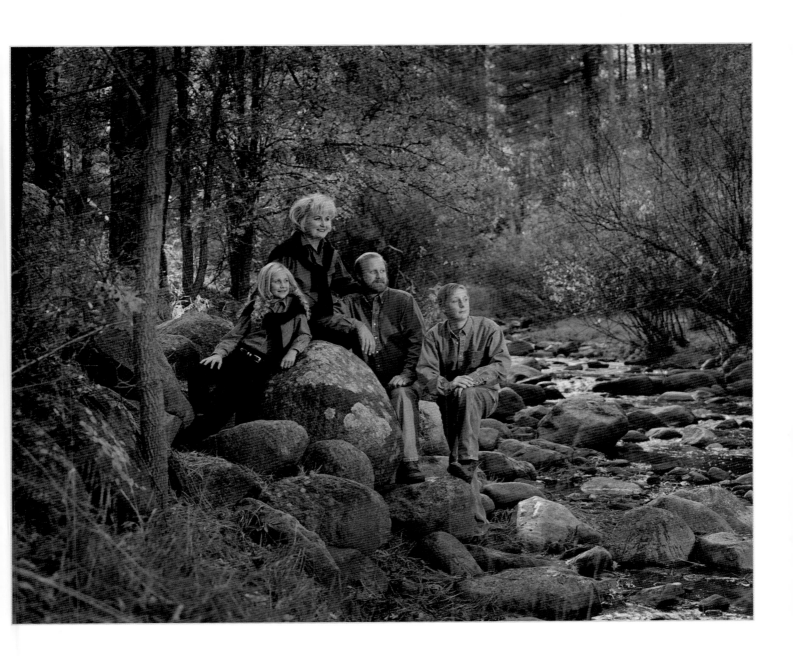

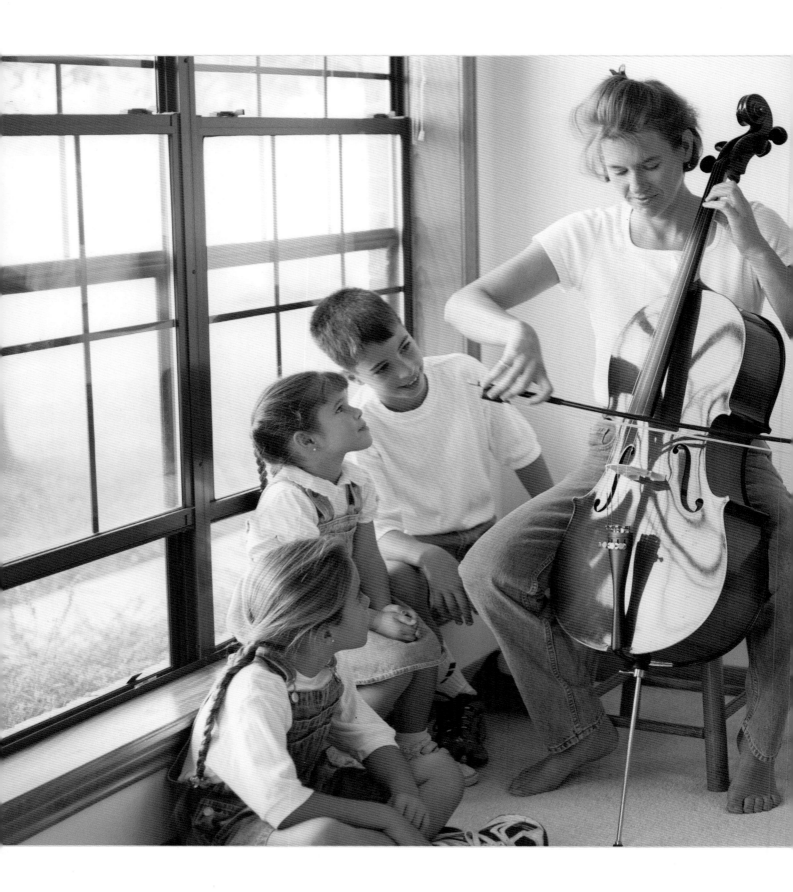

Props

While talking with this family about activities they enjoyed, **I discovered the mother and son were learning to play the cello.** That fact provided the concept for the shoot. Using this prop gave the subjects something to do in the portrait, and makes the image seem very natural. I love the way the children are looking at the mother. The young man seems to be watching the technique his mother uses in her playing, while the girls are focused on the mother's face.

○ LIGHTING

The mother's light and airy bedroom featured these large windows. These provided a nice directional light on the mother's face, while still sufficiently illuminating the children's faces.

○ POSING

To keep everyone on a different level, I sat the young man (who was the tallest child) on the window ledge. I sat the smaller girl next to him. If I had put the taller girl on the ledge, her head would have been on about the same level as her brother's—exactly what I wanted to eliminate! Instead, I sat the taller daughter on the floor.

○ PHOTOGRAPHY

Photographically, this image is quite simple. Because of the overall illumination in the room, no supplemental lighting or reflector was needed. I simply placed the meter at the subject, pointing it back towards the camera. The camera was set at 1/60 at F/8. I used a 120mm lens. Using the F/8 aperture allowed me to create plenty of depth of field and keep everyone in focus.

○ PSYCHOLOGY

Giving the family something to do kept me from having to meticulously pose or direct the family. All I had to do was talk to them about what was going on—mom's playing—while I was making the image. Saying things like, "Is Mom playing it right?" or "Isn't she doing a great job?" provided plenty of direction for the kids.

○ ADDITIONAL SHOT

Since the son was also learning to play the cello, I created a portrait of him by simply seating him where the mother had been for the group portrait. Since I was working solely with natural light and no reflectors, no additional setup or adjustment was required.

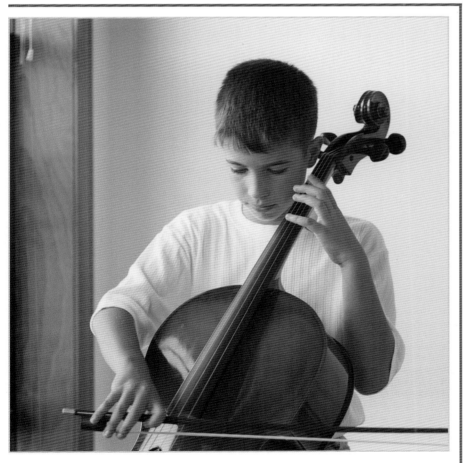

Posing on the Ground

This is triangular posing at its best. I started by a sitting mother on a 12"x12" wooden block covered with a piece of green indoor/outdoor carpet. If you look closely at the print below you can see it under the mother (by the girl on the left side). In the final print (facing page), that area was burned down (printed darker) so you cannot see it. Once the mother was in place, I brought the father in behind his wife. He is kneeling on another piece of this green carpet. Kneeling is a great pose for men because, by changing the bend of their legs, you can change their height. The difference between kneeling straight up and sitting back on your foot can change the height of the head by 10" to 18". Finally, **I brought the two girls in to complete the triangular composition.** By placing each girl with her legs extended out away from the center of the image, I completed the pleasing composition.

○ BACKGROUND

I chose this area behind my studio for the portrait because it gave a tremendous amount of depth to the image. By photographing along a line of trees (as opposed to photographing into the trees), you create the illusion of being able to walk into the photograph.

○ LIGHTING

The line of trees on the right side of the photograph blocks off the light from that side, giving direction to the lighting.

○ PHOTOGRAPHY

I have included two versions of this print, the smaller image is a straight print, the larger image is custom printed. In the custom printed image I was able, in the darkroom, to darken areas of the print that were distracting. This keeps your eyes from wandering off the edge of the photograph. I also darkened the hands, feet and legs of the young girls. Again, this keeps your eyes on the subjects.

○ EVALUATING YOUR IMAGES

I try to look objectively at my photographs. While I really enjoy this image, there are a few things I could have done to make it even better. The clothing is almost perfect—the only exception is the youngest girl on the left side of the image. Her outfit has too many patterns for me. Also, her left hand is coming straight toward the camera. I should have had her bend her arm more, bringing it closer to her body. This would have the kept the arm from being foreshortened. I should also have had the mother's left hand gently touch the back of the girl on the right. This would have kept you from seeing that bright spot her hand creates in the middle of the image.

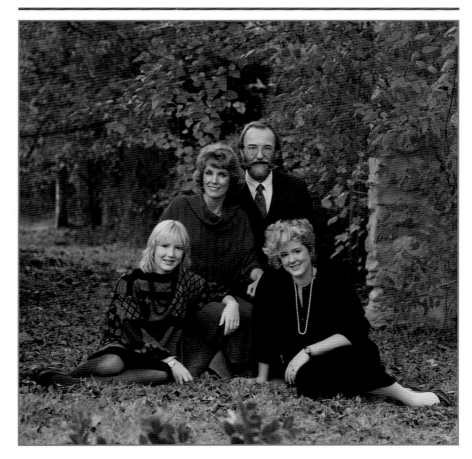

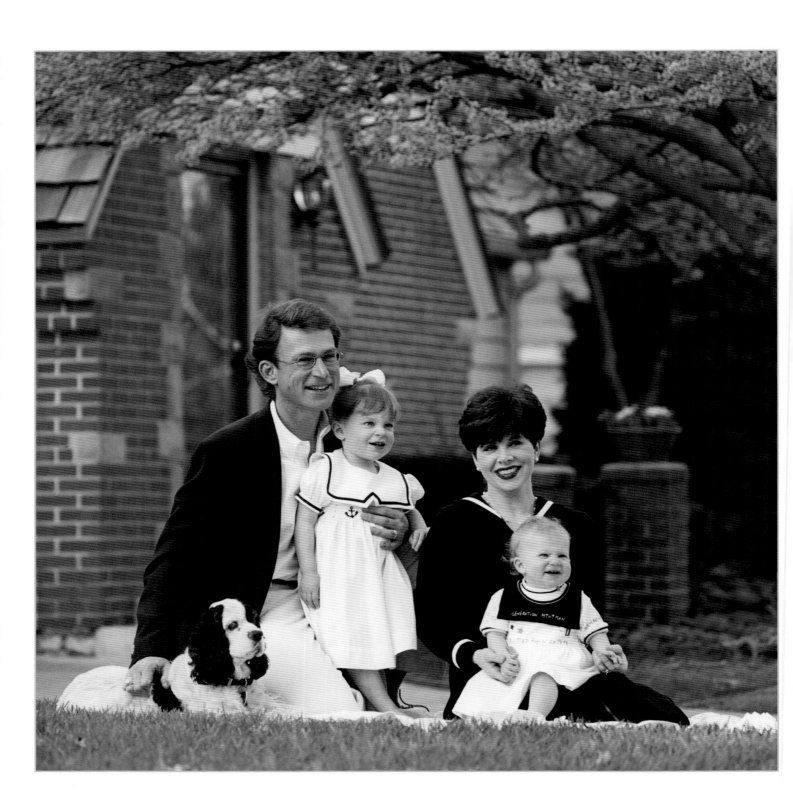

Working with Kids

When working with more than one child, I will sometimes keep one of the children out of the posed group until the very end. This is especially useful with active children. **I get everyone else into position, set the camera up, do the metering and get everything else done before I put in the active child.** Sometimes, I hold up the child and let her look through the camera at the rest of the family. Then I ask her, "Where would be a good place to place you in the photograph?" It's amazing how many times kids will pick a great spot. Then I whispered in the child's ear, "Since you are the big girl, I need you to be my helper. Will you help me? I need you to keep your attention on X (the child's mom, my assistant, etc.) so I can watch your little sister. Since she is so little, she doesn't know how to act. You can be the big sister and look great in the photograph."

○ POSE

I posed this family on the ground to best accommodate the dog. It also helped to keep all of the faces close together. I started with the mother and placed the baby on her lap. Then I brought in dad and then the dog. Again, I try to give each person's face its own level. You should also be careful not to let two faces line up one above the other. This is often difficult when a small child is sitting on someone's lap. Notice that the mother is holding the baby's hands. This accomplishes two things. First, it adds intimacy between the mother and baby. Second, it keeps the baby's hands out of her face and mouth.

○ BACKGROUND

The background is the front of the family's house and a beautiful flowering tree in their front yard. For the shot, we were actually sitting on the front lawn of their neighbor's house, looking across it to the subjects' house.

We also spread a blanket on the grass to keep the family's clothing clean. By using a low camera angle and a 250mm lens, I was able to effectively reduce the visibility of the blanket.

○ PHOTOGRAPHY

The 250mm lens worked well for me in several ways. First, it compressed the background, placing it reasonably out of focus while still keeping the house recognizable. It also provided a narrow angle of view, allowing me to leave out the garage and most of the house on the other side.

○ LIGHTING

The light is coming from an open sky directly behind the camera. I chose a fairly flat lighting situation because I wasn't sure in which direction everyone would be looking in the final image.

○ INTO THE LIGHT

To help keep everyone looking the same direction, I employed the help of my wife, Barbara. She would run up to the children and quickly run back, capturing their attention and creating nice expressions. Since the lighting was very flat, this easy ploy was enough to keep good illumination on all the faces.

This photograph was taken in a hotel lobby while the family was on a vacation. **Because we were working in a public space, I didn't have a lot of control over background, props or furniture.** However, I was able to work with these large arm chairs, which are great for posing families. I brought the two chairs fairly close together and turned them toward the center.

○ POSING

I placed one woman in the chair on the left, with her husband sitting on the arm behind her. I made sure that his head and her head did not line up vertically, then placed the baby in her lap. Next, I brought the lady on the right of the photograph to the chair, with her husband posed similarly behind her. I found a small bench for the woman in the middle. The mom and dad were posed next. I had kept the young girl out of the photograph until this point, so at the last minute, I placed the older child and myself in the photograph (yes, this is my family). I had already set up the camera, and had previously made arrangements with an employee of the hotel to push the button.

○ PROPS

The table, boat and lighthouse were already present in the lobby. They are a great reminder of the nautical decor and the activities of the weekend. I repositioned the lighthouse so it would fill the otherwise blank area in the photograph. My two sons and my oldest sister's son were unable to be in the photograph. If they had been there, I would have removed the lighthouse and placed people in that area of the photograph.

○ LIGHTING

The light was coming from two large windows to the right of the camera. Because the light was coming from that direction, I had all of the people in the photograph turn their faces toward the light. Because the girl on the right was closer to the doors I knew she and the others on that side, would be illuminated more than those farther from the window. For this reason, I shifted the entire group counterclockwise to put each person approximately the same distance from the light source. To add a tiny bit of illumination to the darker side of the faces I used a small electronic flash at the camera position. To soften the light of the flash, I pointed it straight up and attached a piece of white paper to the back. This spread the light out, and added a very soft and natural amount of illumination to keep the image from being too contrasty.

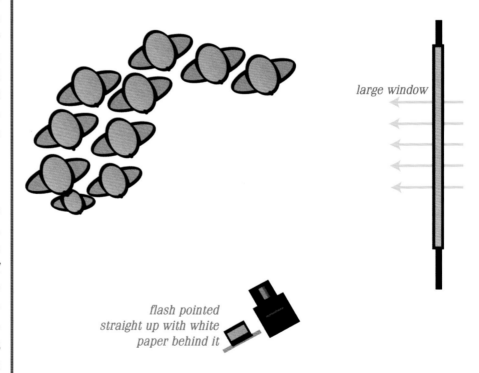

large window

flash pointed straight up with white paper behind it

Vacation Portrait

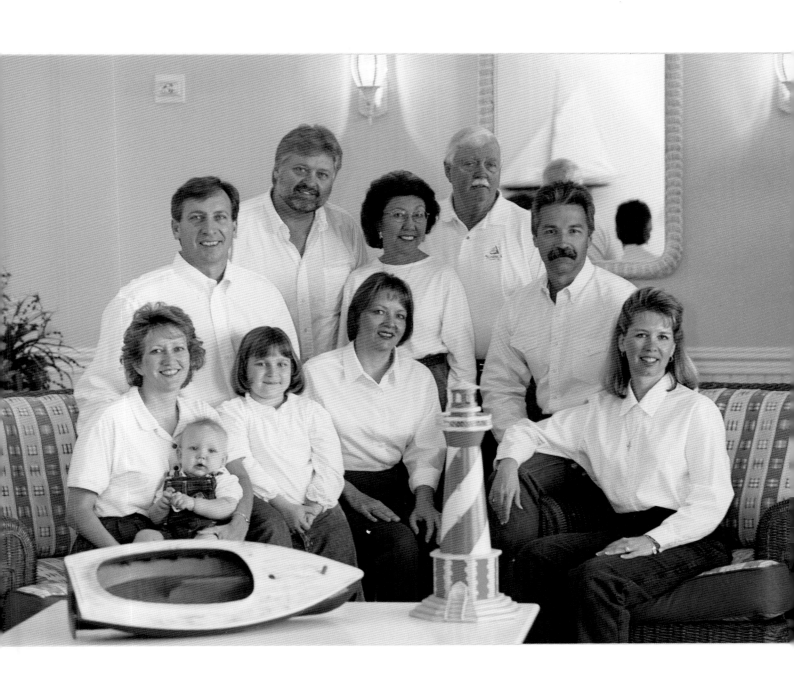

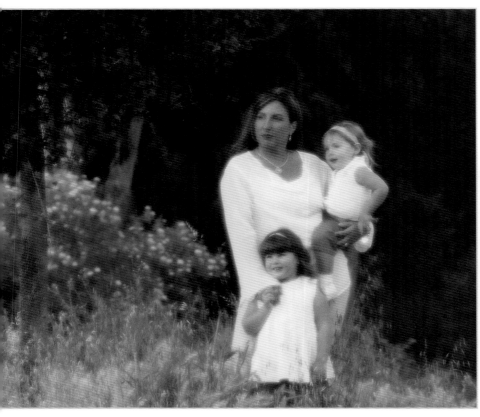

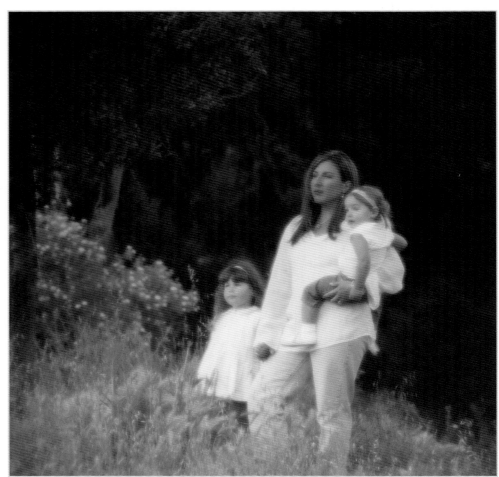

Filtration

Here are several photographs I made of a family while I was teaching at the California Photographic Workshops. We did a series of images of this family, in several places around the campus.

○ POSING

The posing was very natural—I basically placed the subjects in whatever area that would provide the best illumination on the faces. In this scenic area, this usually meant I also had a good background. **With a location selected, I simply directed the subjects to different poses.** The little girl wanted to be held by the mother, so we posed everyone else around the two of them.

○ BACKGROUND

The family was posed in a small field with trees in the background that were about 200 yards away, across a small valley. The light was not hitting the background so it went quite dark, which makes the subjects really stand out.

○ PHOTOGRAPHY

I turned the subjects toward the sun and waited until the sun dropped behind the horizon. Prior to the sun dropping, the illumination was too bright and contrasty. By waiting a few minutes, we got great light from the sun—soft but directional. For the portrait, I chose a 250mm lens, which gave great separation from the background. Because of the narrow angle of view of the lens, I was able to keep the sky from showing in the photographs. Of course, I also used a tripod and a cable release to eliminate motion or blurriness in the photographs. The exposure was 1/8 second, with the lens wide open at F/5.6.

○ FILTRATION

I also used a Lindahl Coral Soft Focus Filter. This added warmth to the faces, and an overall softness to the image. I really enjoyed the effect of this filter.

light from setting sun

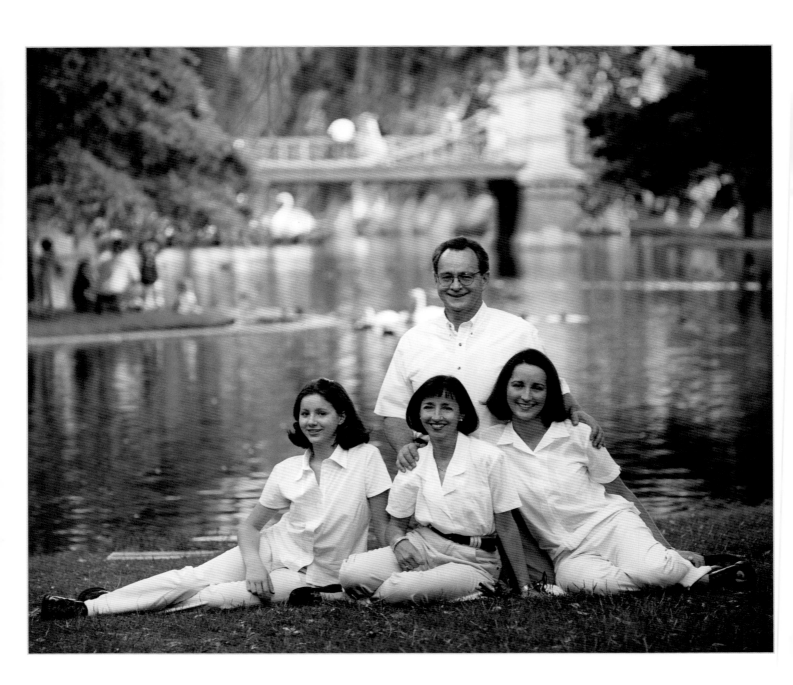

At Boston Gardens

This family portrait was taken in a famous park in downtown Boston, Massachusetts. The bridge in the background is a quite famous location in the city.

⬤ POSING

I did a series of poses with this family. **This is a basic triangular pose with the mom sitting and the dad kneeling behind her.** The two girls were seated on either side of their mother. I had the girls sit with their legs pointed out in opposite directions to create the base of the triangle.

⬤ BACKGROUND

I used a 250mm lens to throw the background out of focus. This reduced potential distraction from it, while ensuring that the famous bridge remained recognizable. Notice how nice the clothing is, with the unified light tones tying the family together and letting your attention go to their faces, rather than their clothes. Having everyone dressing alike makes for great family photography.

⬤ PHOTOGRAPHY

We waited to create this portrait until the light was just right. There was open sky behind and to the left of the camera, illuminating the faces. Because the light was off to the side and not directly behind the camera, it had a nice directional quality.

light from open sky

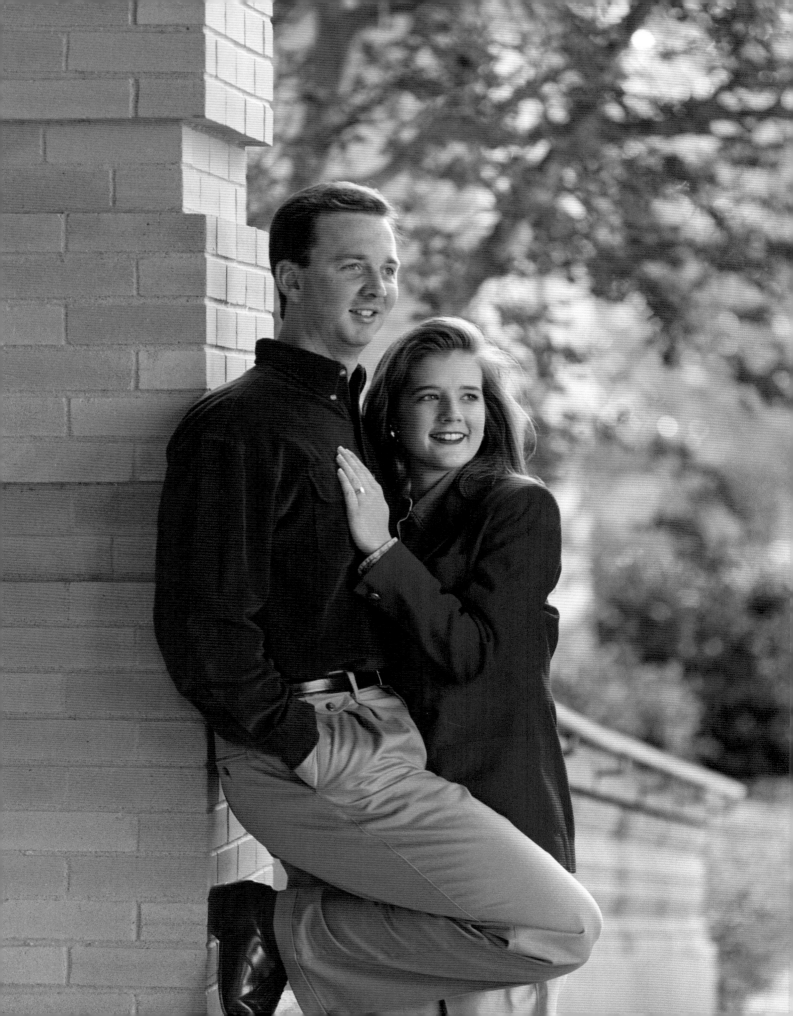

Engagement Portrait

These two images were made at the same spot on the Texas A&M campus, but from different sides of the stone porch. In the three-quarter length image on the opposite page, I had the young man lean against the column with one knee raised, then I posed the young lady next to him. She naturally placed her hand on the young man's chest. **Conveniently, it helped to show off her new ring!** In the photograph below, the setup was reversed. I posed the young lady against the column with her knee raised, then moved in the young man. The couple was then photographed while holding hands—showing their close, romantic relationship.

⊙ BACKGROUND

In both images the background is the trees and greenery in front of the building. Because this creates a complicated pattern with the potential for distracting hotspots, it was important to break it up by throwing it out of focus. To do this, I chose a 250mm lens. This lens adds separation to the subjects, making them stand out better from their surroundings.

⊙ LIGHTING

In both cases, the light for the portrait came from the open sky and illuminates the faces of the subjects from the side. The porch overhead blocks light from the top.

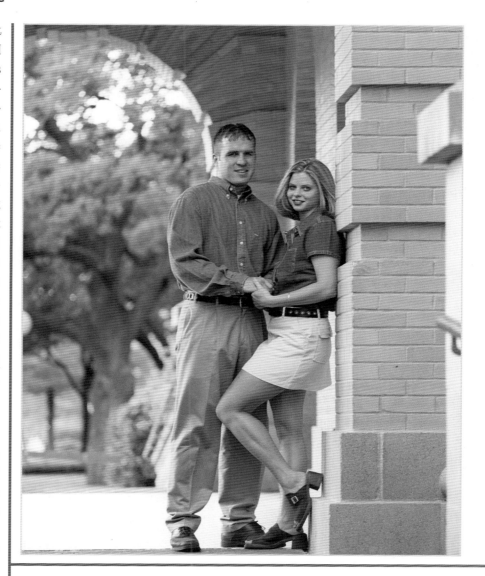

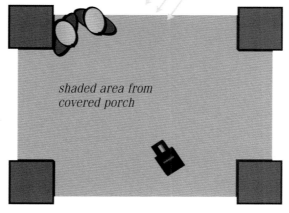

light from open sky

shaded area from covered porch

Here are two different views of a couple on a bridge. In the photograph shown below, I had the gentleman place his left foot on the rail of the bridge. Then I brought his fiancee to him, and she placed her right hand on his leg. **They both looked off toward the source of light.** In the larger photograph, the couple stood side by side with the man's arm around the woman's waist. It's a simple standing pose, with couple and their dogs facing into the light. I really think the animals add a lot to the casualness of the photograph.

⊙ SETTING

This simple, arched bridge in a grove of trees is both the prop and the background for the portrait. It is located at a golf course, and is a place where I photograph a lot of weddings.

⊙ LIGHTING

The image to the right was taken before the sun had dropped below the horizon. This means that the late afternoon sun is actually shining directly on the subjects. As you can see, it results in a much different quality than the light in the image on the facing page, where the sun had actually dropped behind the trees and the illumination came from the open sky.

⊙ PHOTOGRAPHY AND FILTRATION

In both images, I used a 250mm lens. In the image on the facing page, I also used a Lindahl Coral Soft Focus filter.

On the Bridge

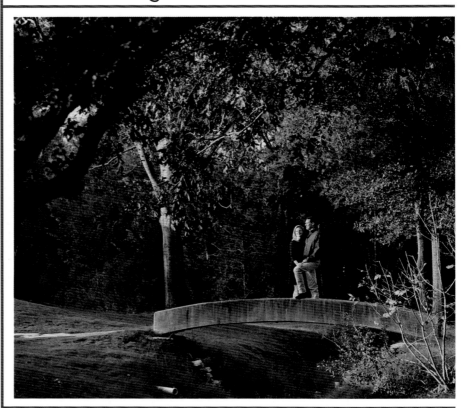

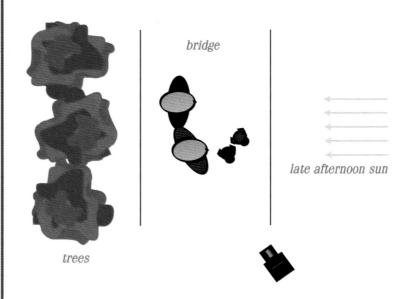

bridge

late afternoon sun

trees

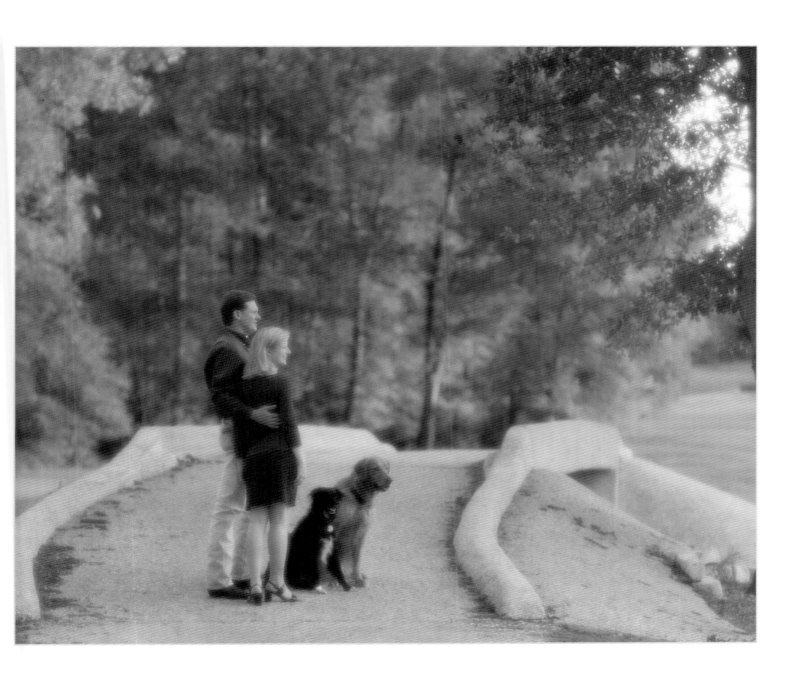

Translucent Light Modifier

In all three of these photos, there was direct sunlight hitting the young lady. To soften and spread out the light, I chose a translucent light modifier. The translucent material looks like a very thin white bedsheet, and when placed between the light source and the subject, it helps to create softer, more flattering light with less harsh shadows. In the image of her peeking out from behind the tree (lower right), you can actually see the shadow of the large, round translucent modifier on the tree. If you look at the top of the tree trunk, you can see what it

would have looked like if I had let the sun hit her face directly. By simply holding the translucent light modifier between the sun and the subject I was able to get this quality of light on her face.

The other two images were created using the same technique to create beautiful wraparound light on her face. Notice that **the light still has direction, but is very soft with light, open shadows.**

The translucent modifier is a powerful tool to have with you when you are photographing outdoors and using natural light. It spreads out the light to create a beautiful soft light.

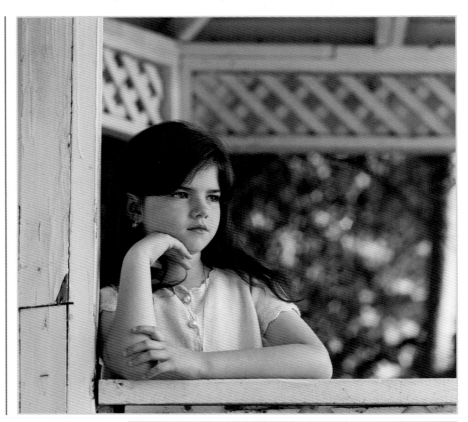

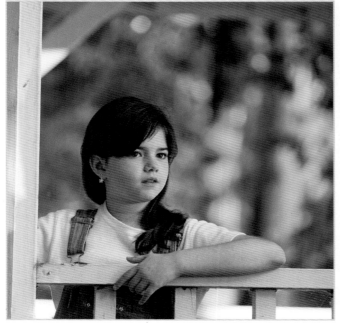

Two Views with Two Lenses

In these two images the difference is the lens selection and distance between the camera and the subjects.

⊙ 120MM LENS

In the photograph with the water showing (top) I used a 120mm lens. The trees block the light coming from behind and creating direction in the light. This is a very nice image, but I find the water a little distracting.

⊙ 250MM LENS

I changed the lens to the 250mm lens and moved back ten to fifteen feet, so as to keep the subjects the same size in the frame. I personally like this image the best. **The background is more uniform, more abstract and out of focus—and less distracting.** It allows the subjects to stand out from the background much better.

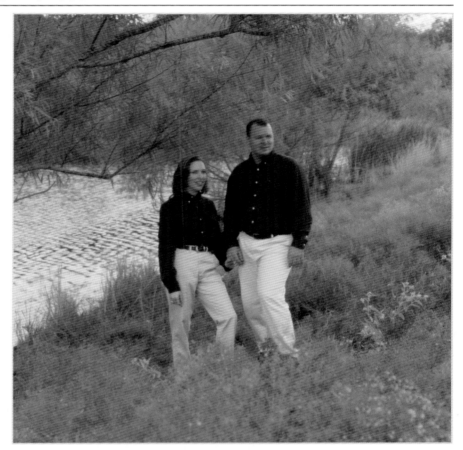

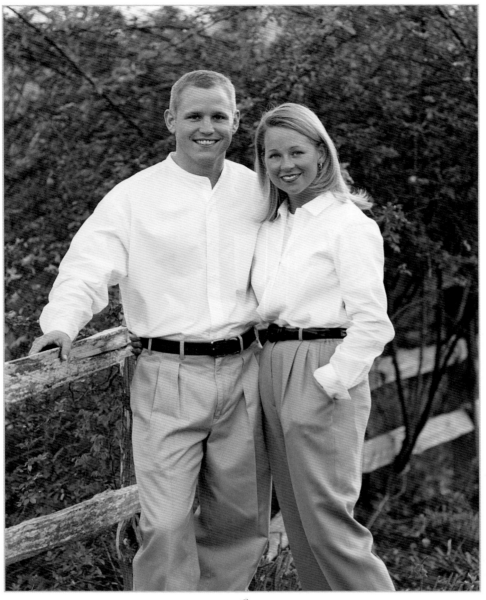

C

A

B

Little Things Make a Big Difference

In this series of photographs, let's talk about posing. In photograph A, look at the heads of the couple. They seem to be tilted away from each other. In photograph B, notice how much nicer the photograph feels when the couples' heads are tilted together. While B is nicer than A, the hands still seem a little distracting to me.

In the final photograph (C), notice how much nicer the image is because of the placement of the hands. Now your eyes are directed from the rail to the young man's arm to the couples' faces, then to the young lady's arm. **The illumination on the faces comes from the open sky behind and to the left of the camera.** Also, notice the highlights on the hair that come from the setting sun filtered through the clouds and striking the backs of their heads.

In photograph D, where the couple is sitting on the steps, you will notice that the sun is higher in the sky and somewhat brighter on the hair. The pose is simple—a triangular shape, starting at the top with the young lady's face and moving down across the young man's face to his elbow, across to her back, and up to her face.

Also, notice how nice the clothing is. I request that subjects dress alike for engagement sessions, because your eye is not distracted by the clothing but is directed to the faces. This, of course, is not mandatory—just a suggestion. Many times couples will bring a second outfit to change into. In fact, if the couple is uncomfortable dressing alike, I strongly encourage them to use the second outfit and choose anything they like. However, I like the images where they are dressed alike.

D

Looking Natural

For this couple, we went out to document a regular occurrence for them—the feeding of the cows. In Texas, there are many "hobby ranches"—ranches that are not big enough to produce sufficient income to support a family, but rather serve as a way to connect with the land and the animals. For many people, these operations are a relaxing pastime. They are scattered all around the many small towns and cities across Texas. So, **the ritual of this couple going out together to take care of the cows and their ranch has become a part of their life.**

○ POSE

I just watched and photographed as the couple went about their routine. When we talk about posing in photographs, much of what I do with clients is more guidance than actual posing. Most people just aren't comfortable when formally posed, so I like to let them pose themselves with a little guidance. With this couple, I would occasionally suggest an action or

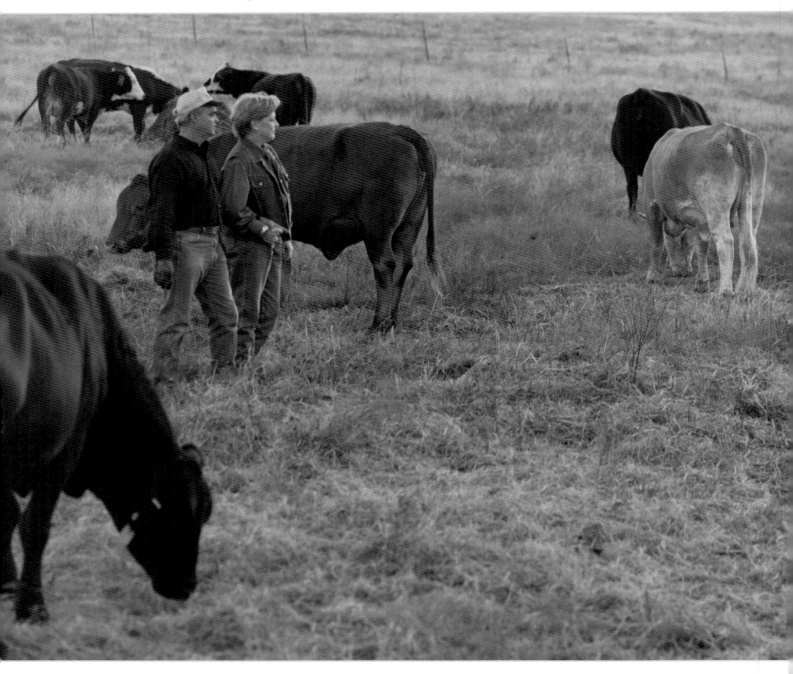

have them repeat something they had already done so that I could get another shot or a different angle. This image came near the end of the session as the couple was relaxing and enjoying a job well done. It reflects the pleasant feeling of being in the country, working hard, then enjoying each other's company and a beautiful sunset.

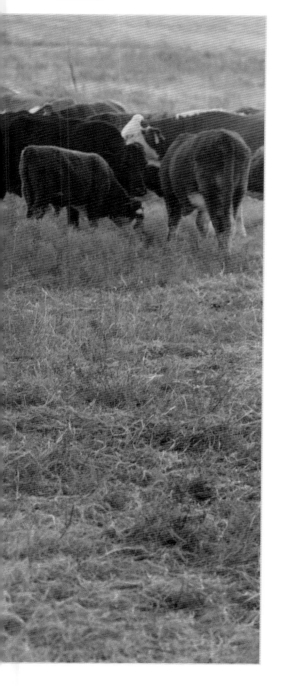

○ BACKGROUND

For the shoot, I found a place that would photograph well—one with no electric poles or other distractions in the background. I chose a high camera angle to keep the sky out of the image and create a uniform background of the field and the cows. For some added elevation, I climbed into the back of the pickup truck. A low camera angle would have given me a nice skyline, but we would not have been able to see and enjoy the animals as well.

○ PHOTOGRAPHY

The late afternoon sun, which had not quite dropped below the horizon, provided a warm color of light. To utilize this type of light, you must plan ahead, wait for just the right moment and work quickly. The sweetest part of the light only lasts a few minutes—a few minutes too early and the sun is too bright and contrasty; a few minutes too late and it looses its

warm glow. Even though it only lasts a short time, this light is definitely worth the wait. To meter this situation, I used the flat disk setting on my incident meter. Instead of pointing the meter at the camera or at the light source, **I turned it at about a 45° angle to catch some of the direct light from the sun** without allowing the full brightness to strike the meter. This gave me an "averaged" reading. The most important thing to remember in this lighting situation is to meter often—the light value changes every minute or so as the sun sets.

○ PSYCHOLOGY

People react and look most natural when they are doing something. I know that the best photographs of *me* are taken when I am not aware of the camera, and I am not posing. So, the key to natural expressions is let people be themselves, and catch them looking good or comfortable.

light from setting sun

Posing Women

When posing women, you must be especially careful to select the most flattering angle for each subject. Most women want to look thin and feminine. For this reason, **select an angle of the body that accents your subject's natural femininity and slenderizes her figure.** This will usually be the best pose.

◉ SLOW DOWN

The best skill you can develop for photographing women is to learn to appreciate the beauty of all women. A friend and fellow photographer, Doran Smith, has taught me a lot about photographing women. An excellent photographer of women and children, he has provided me with great insight into romantic portraits of women. One of the things he has taught me is to slow down. As a wedding photographer, I tend to work at high speed all the time. The bride doesn't want to spend any more time on photography than is absolutely necessary. Thus, I have to work quickly to keep the photographic time to a minimum. When doing sensitive, romantic portraiture, being fast is not an asset. In fact, going slower makes for better portraits.

◉ POLAROIDS

One thing that will slow you down and make you see the little things that make a portrait great, is using Polaroid film. That is one of the reasons I use a professional camera like the Hasselblad. You can use a special back on the camera that allows you to use Polaroid film. That way you can preview your image using the exact same lens, position and camera settings as you will with your regular film—but you get to see it in sixty seconds. If a correction needs to be made, you can make it before going to film.

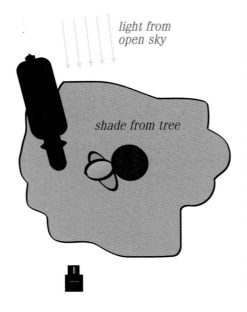

light from open sky

shade from tree

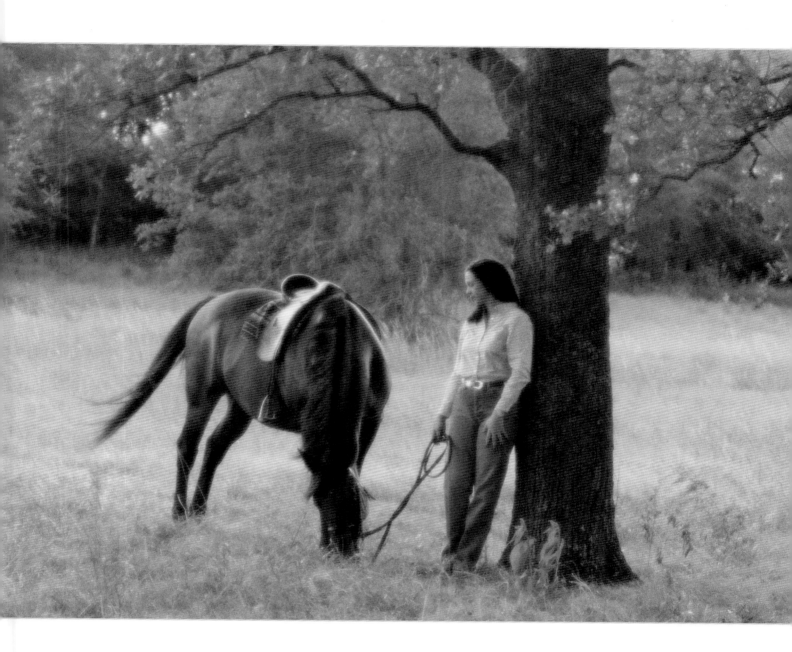

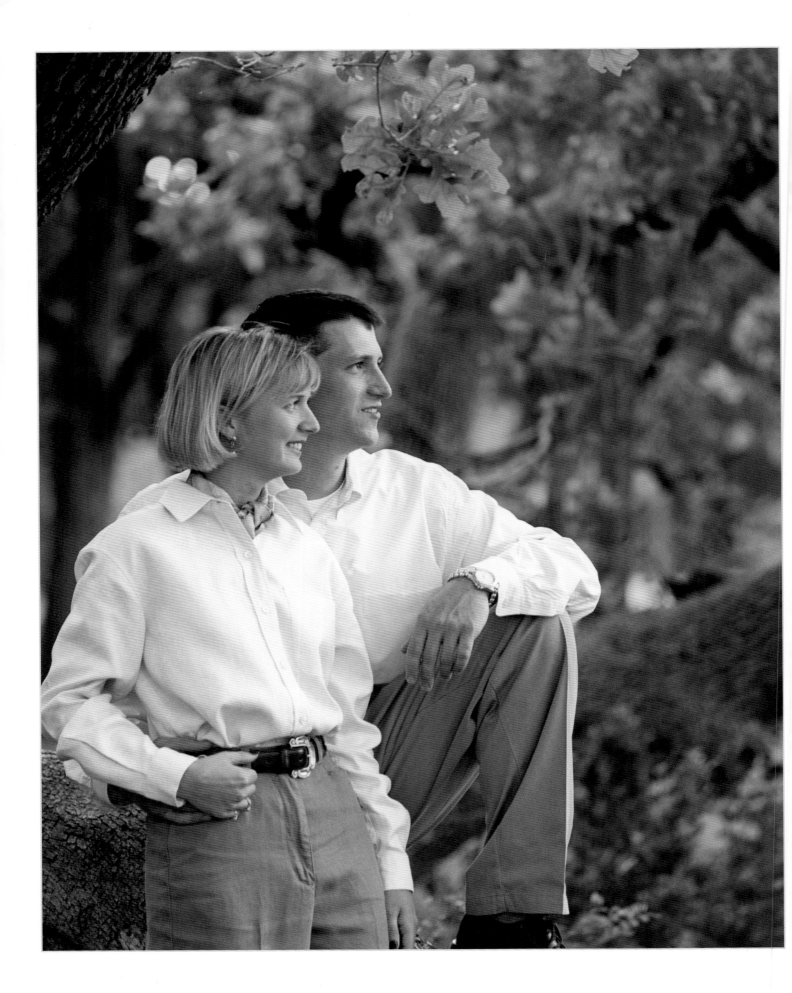

POSING COUPLES

When photographing couples, I use two basic poses. The first is the dance pose, where a couple stands facing each other. **I then "open up" the pose by having the couple separate the sides of their bodies closest to the camera.** This forms an inverted V-shape. The second pose, what I call the "prom pose," is shown here. This is where one person, usually the woman, stands with his/her back against the front of the person behind. I call this the "prom pose" because I use it a lot when photographing proms, where the pose allows both the corsage and boutonniere to show, since both are worn on the left side.

BACKGROUND

The background is simply the trees and greenery on our 110 acre property. I placed it out of focus by using a 250mm lens and a large aperture of F/5.6.

LIGHTING

Photographing in the late afternoon means the sun is low—near the horizon. This keeps light from directly hitting the background and causing hot spots. The most important aspect of this photograph is the lighting. If you notice, there is a nice lighting pattern on the faces. It is brighter on the "mask of the face" (the front of the face from ear to ear and chin to hairline) than on the side of the face that you can see. The reason for the nice lighting pattern is that there is a medium-size patch of blue sky in front of the couple.

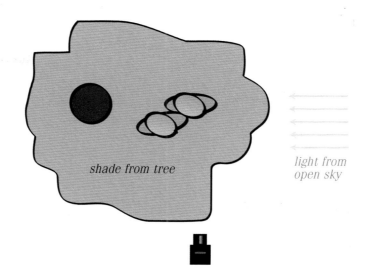

shade from tree

light from open sky

If they had turned their faces toward the camera (changing the directional relationship between their faces and the light), the lighting would have changed to a split lighting pattern. This means that the light would have illuminated one side of the face and not the other; it would not have been as flattering.

If I had moved the camera to a position directly in front of the couple (leaving their faces in the same position as they are here), both sides of their faces would have been equally illuminated. The result is called flat lighting, because it "flattens the face" (in terms of lighting). With this type of lighting, the face looses its beautiful shape.

FINDING GREAT LIGHT

If you can learn to find great light, you can make great natural light photographs. When I teach photographers to find the light outdoors, I use the saying, "Blue sky is our friend." If you can find a patch of blue sky (or white sky on a cloudy day) and move the subjects so that the light from the blue sky completely illuminates one side of the face, and partially illuminates the other side (leaving part of this side in shadow), you will have found great light. The reason for wanting part of the face in shadow is that it shapes the face. The amount of the shadow—the ratio between the bright side and the darker side—can be controlled by the photographer and adjusted to suit his or her taste.

Posing Couples

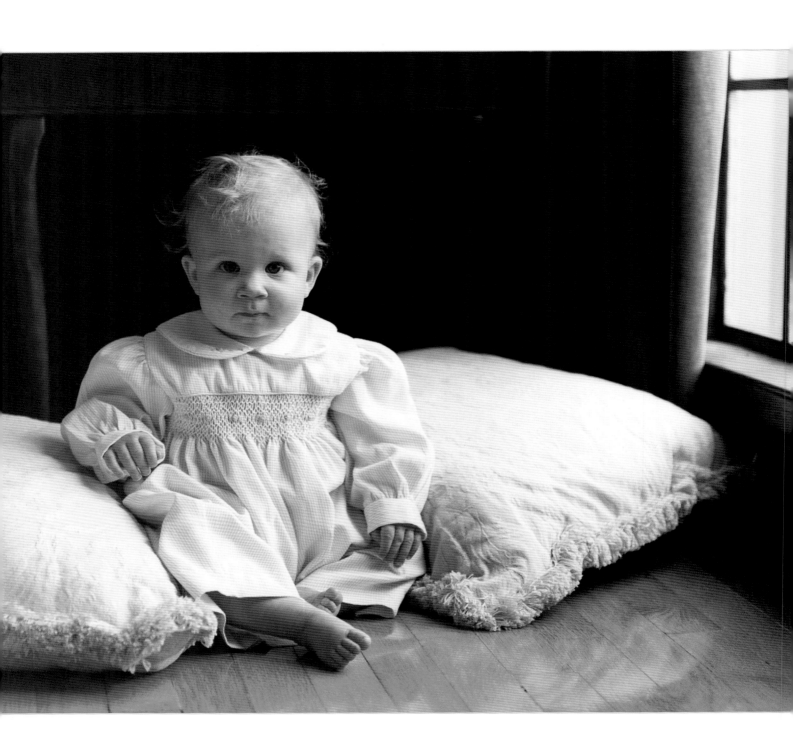

Window Light

Each of the girls are posed facing straight into the camera. **Typically, I would turn their bodies toward or away from the window.** However, given the simplicity of the background and lighting, and the pensive expression on the young ladies' faces, the pose seems to fit. I had the older sister sit on a small stool, but to prevent the younger girl from falling, I sat her directly on the floor and surrounded her with pillows.

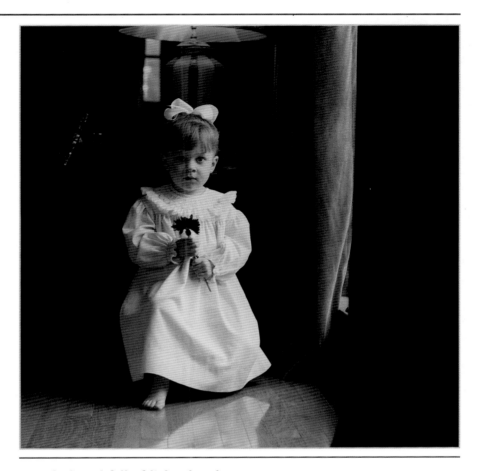

◉ PROP

We gave the older girl the simple, single flower to hold. I did several images with it, and in some she had the flower too high, in others it covered too much of her face. Then, while quietly talking to her, she lowered the flower to this position and I made the exposure.

◉ PSYCHOLOGY

One thing I have found when working with children is that young kids need more stimulation—more talking, noise making, and toy handling. With that same amount of visual and verbal stimulation, many three- to five–year-old children will end up laughing and bouncing off the walls. Because of this, you should use only the amount of stimulation that is needed to capture the child's attention and get the expression you need.

◉ PHOTOGRAPHY

Since the window was relatively narrow (about 36"), and the room was dark and full of light-absorbing colors and materials, I chose to use a silver reflector opposite the window and slightly forward of the subject. This kept the shadow side of the face from becoming too dark.

Because of the size of the room and its layout, I couldn't back up any further, so I used a 120mm lens.

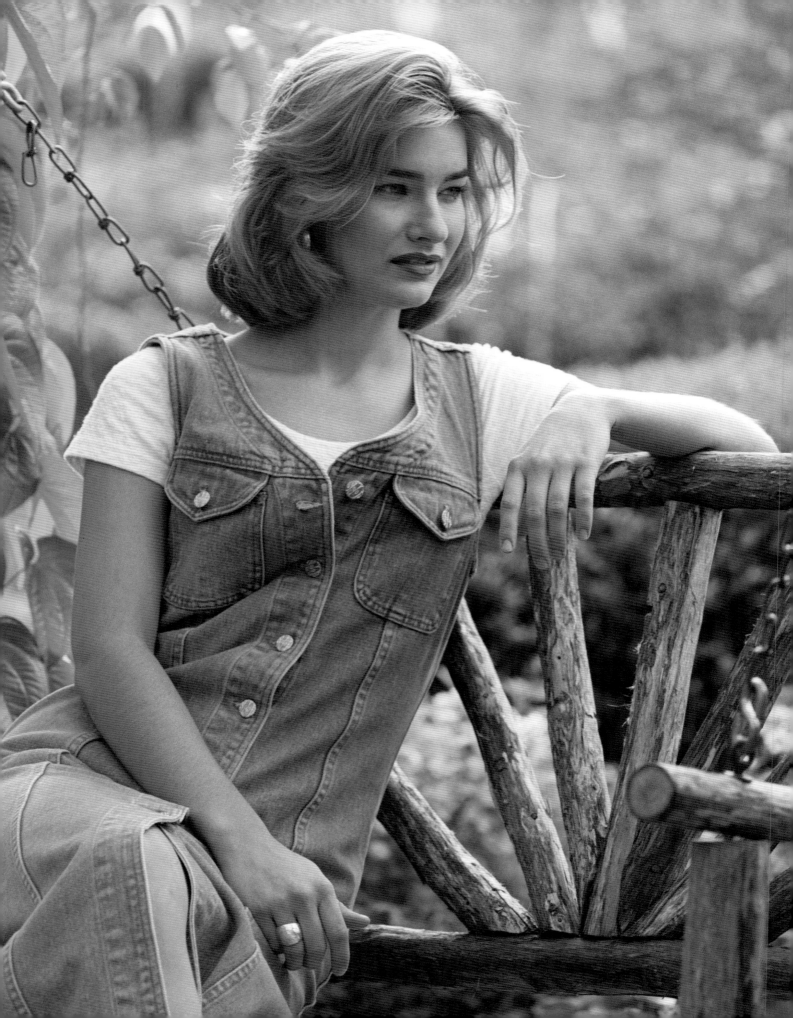

Senior Portrait

The pose for this senior portrait is simple. The young lady is sitting on a swing, with one arm resting on its back. **I turned her body away from the light in order to add texture to her clothing as the light skims across it.** Notice the way she is sitting on one hip, rather than flatly on both hips. This adds a sense of movement to the pose. I also made sure that the

subject's right shoulder was slightly lower than the other, then had her tilt her head slightly toward the high shoulder. The result is a beautifully graceful "S" curve to the body. It starts at the legs, moves through the hips, to the shoulders, and then to the head.

○ LIGHTING

As I've said time and again, one of the most important factors in choosing an outdoor location to photograph a subject is whether or not the spot has good light. You need a medium to large area of open sky that is perpendicular to the camera and subject. You don't want the open sky behind the subject, because that will give you backlighting and not light the face—which is the most important area to light in most portraits. You do not want the open sky directly behind the camera, because that will give you flat lighting. You also don't want the open sky to be directly above the subject, because that will give you top lighting. This causes "raccoon eyes"—those dark, unflattering shadows that can obscure the eyes of the subject.

The reason for the success of this particular image is the characteristics of the location at which it

was created. There was a building behind me and to my left, which gave direction to the light. There was an arbor as a roof above the girl's head to stop the top light. And, most importantly, there was open sky to my right. I simply turned the subject's face into the light (notice the small triangular patch of light on her right cheek).

○ METERING

To meter this situation, I pointed the flat disk on my incident meter at the camera. This gave me a reading of 1/60 at F/5.6. Using a 250mm lens placed the background out of focus, and added separation—helping the subject to stand out from the background.

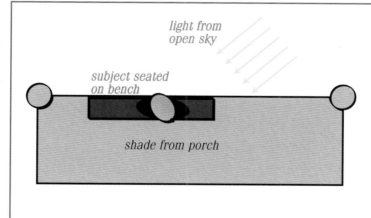

Specialty Subjects

When working with a speciality subject, such as this cadet in a uniform with all the accessories, rely on the subject to inform you of special posing requirements. **This young lady knew exactly how she wanted to pose.** I just made sure that the lighting and her body position was right. For example, I turned her face slightly toward the camera—just short of a pure profile—to accommodate the emblem on the hat, which did not look right in a perfect profile.

◉ BACKGROUND

We chose this particular spot on the Texas A&M campus because of the statue in the background. Anyone who knows that campus knows the place, and the statue. It's a background element that defines the location to anyone who's been there. Subject placement is important in this image. I wanted the cadet in the lower right-hand corner with the statue higher and in the opposite corner. I also chose to frame the young lady within the column behind her, but off centered in it. Choosing a light-colored column helped the cadet 's uniform stand out better.

◉ PHOTOGRAPHY

I chose the 500mm lens for this image. The long focal length allowed me to place the subject in a place that had tree branches overhead (to block the top light), and still allowed for open sky in front of her. The long lens expanded the apparent width of the column, keeping her totally within it. It also threw the statue sufficiently out of focus to render it recognizable to those familiar with it, but not distracting.

◉ HATS

When photographing a person in a hat, many times the light cannot get under the brim to light the eyes. In a close-up portrait, this might be a problem. However, in this scenic portrait, the uniform is very much a part of the subject, and the profile identifies who the subject is. Because of the hat, putting light in the eyes would create an almost unnatural look in this photograph. Wearing the hat pushed back, for example, would not be aesthetically pleasing or regulation dress for a cadet. Notice that the light seems to be coming from over the right shoulder of the young lady. This creates a rim light effect that adds texture and detail to the uniform. Since I placed the glove on her left hand (on the shadow side of her body), I was able to retain good detail in the white.

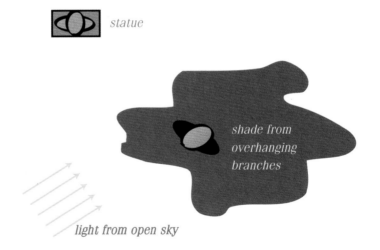

statue

shade from overhanging branches

light from open sky

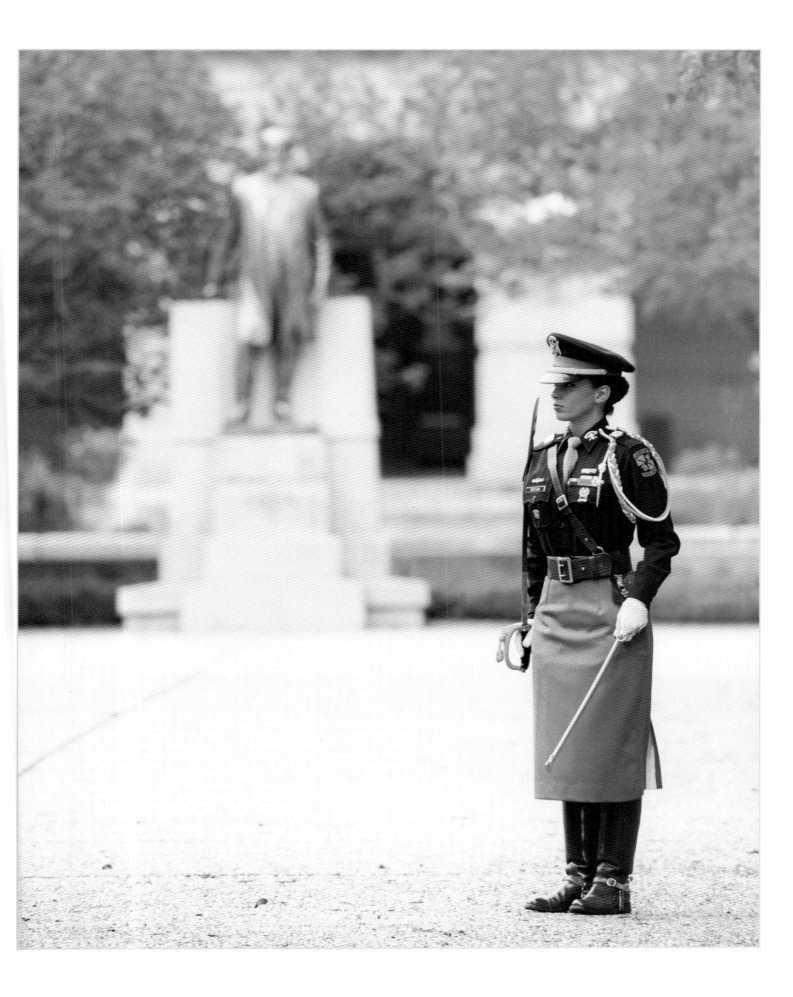

Simple Poses

The pose is simple. I like simple poses—they are easy for the subject to create and hold, and they look natural. **I believe posing is probably fourth on the list of what makes a great photograph**. The others, in no particular order, are: clothing, location and lighting. If these are great, then a simple pose will be sufficient to create an outstanding portrait.

One of the basics for good posing is starting with the feet. Typically, have the subject place their weight on their back foot, the foot farthest away from the camera. This usually causes the subject to drop the back shoulder. This adds motion to the image and keeps the image from being stale or stagnate. I had her look off toward the light direction. I kept the bike straight on to keep it from over powering the subject.

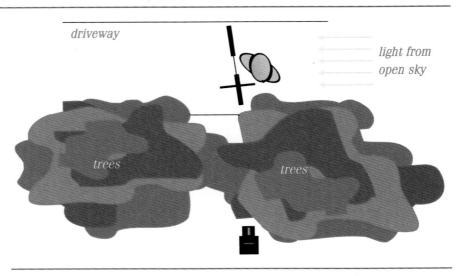

○ BACKGROUND

I chose this particular spot because of the foliage in the foreground and the simple background. The bushes in the foreground give a tunnel effect and draw your attention to the subject. Because they are darker, they also add depth to the image.

○ PHOTOGRAPHY

A 150mm telephoto lens was used to compress the entire image, causing the background to go out of focus and exaggerating the effect of the darker branches. Because of its narrow angle of view, it also shows a smaller section of the background.

○ CAMERA ANGLE

I chose a low camera angle for two reasons. First, it minimized the amount of the driveway that is visible in the portrait. A higher angle would have increased the visibility of the bright concrete—it would have been very distracting. Also, the lower angle allows for the foreground to show more, and adds a feeling of height to the young lady. I guess that's actually three reasons!

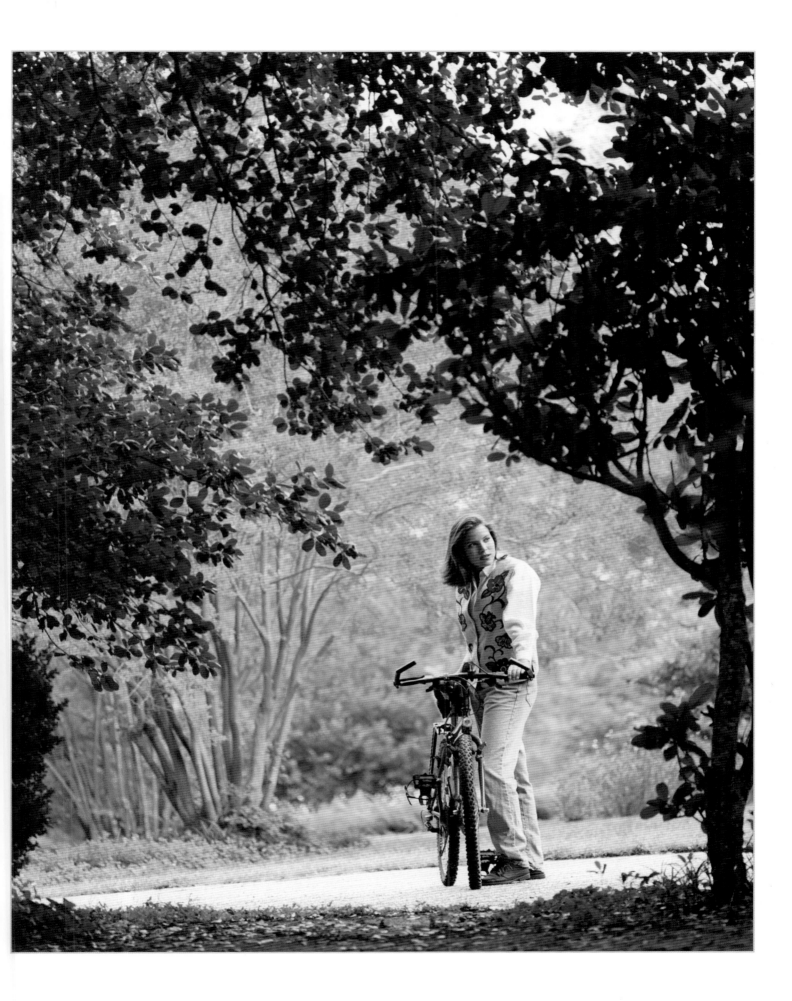

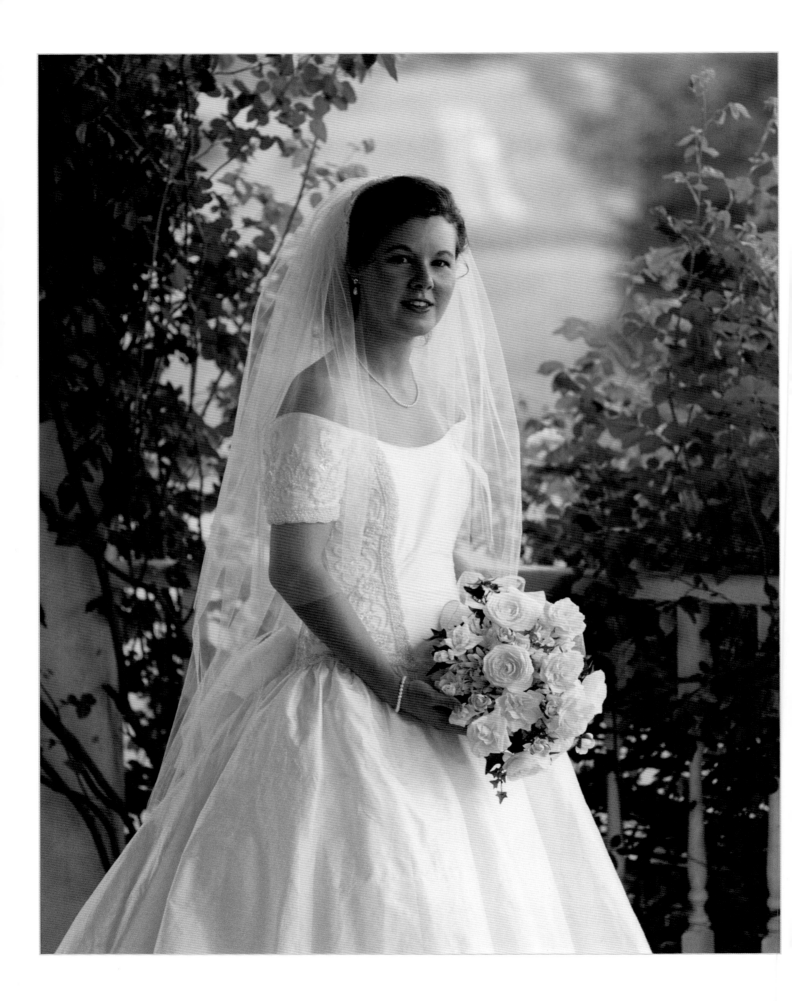

Bridal Portrait Posing

Here is a simple, basic pose for the lovely bride. When posing the body in relationship to the light, there are two fundamental forms to use. One is the basic pose (sometimes called the masculine pose). **This is a pose where the body is turned toward the light, and the face is turned the same direction.** It is sometimes called the masculine pose because it is usually the best pose for men. However, it is also a very nice pose for women—

as you can see in this photograph. The other form is the feminine pose, where the body is turned away from the light and the face is turned back toward the light. The reason it is called the feminine pose is because having the light come across the body adds depth, shape and dimension to the body and the clothing. This is usually better for women than it is for men. This pose also adds to a very feminine "S" curve when combined with a weight shift to the back foot and the lowering of the back shoulder.

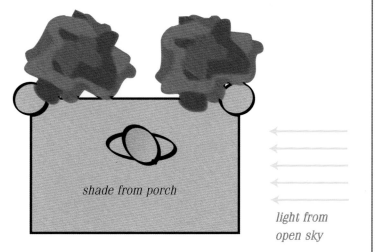

shade from porch

light from open sky

If you use the basic ("masculine") pose for women, you must have good control of the light. Without proper control of the light, the dress and white flowers in this portrait would have lost detail. I was able to keep the detail in the gown by placing the subject far enough under the porch to keep the dress and flower from "burning up" (appearing bright white with no detail).

○ Background

I especially enjoy the effect the dark greenery gives, creating a circular or oval shape to the background. This draws your eye into the background. But, because the background is kept out of focus, your eye comes right back to the subject.

○ Photography

The late afternoon light keeps the background from being too hot. If direct light had been hitting the background, the light areas would have become distracting hot spots. A 250mm lens was used to control the depth of field and amount of focus of the background. I used a small ladder to raise the camera, and place the subject in just the right place in the oval of the light background color.

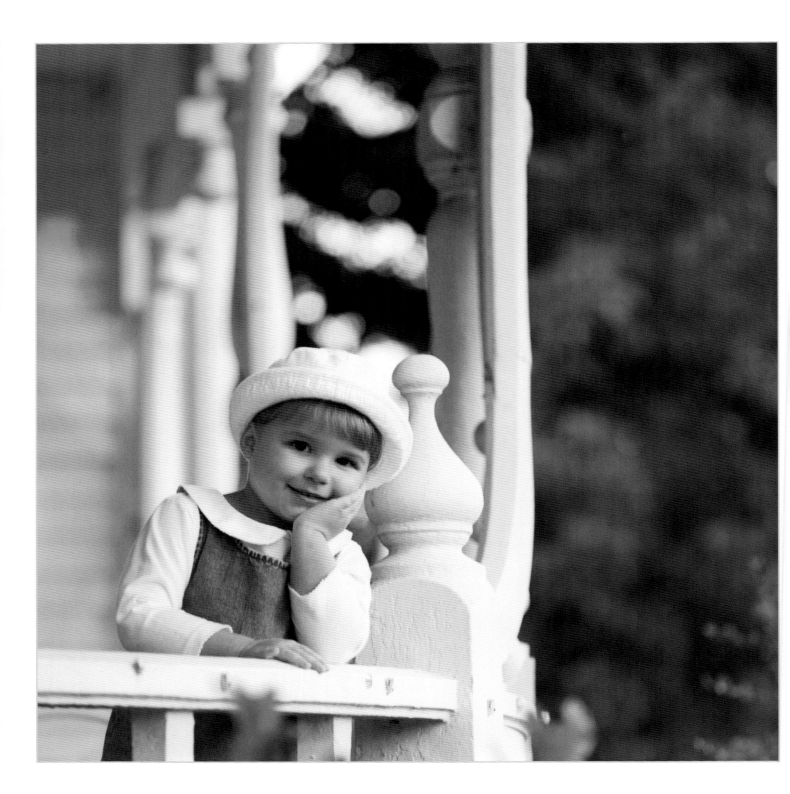

Cropping

The pose is very simple, but believable for this young lady. She just rested against the porch railing. Her hand placed up by her face looks quite natural. **I placed her at this position because of the way the light illuminated her.** I find that the less you actually pose people—the more you let people be natural—the better and more relaxed your subjects will

look. Place your subject in an area that has good light and leave them alone. Many people, like this young lady, will pose themselves in a very nice way.

○ BACKGROUND

This is the porch of a beautiful old house in Caldwell, Texas. It belongs to a neighbor and friend of the young girl's parents. I chose this spot for two reasons. First, I liked the light from the open sky on the right-hand side of the image. Second, I enjoyed the way the post and railing wrapped around and cradled the young girl.

○ LIGHTING

Look at the way the light illuminates the left side of her face and creates a small triangle of light on her right cheek. This is usually called "Rembrandt Lighting"—reminiscent of the great painter.

○ CROPPING

This is one of those images that can be cropped several ways. I enjoy the square image with the young lady in the lower left hand corner. It seems to emphasize her smallness in the big world. A common compositional technique is to draw imaginary lines dividing the image into thirds vertically and horizontally (like a tic-tac-toe board). The points where the lines

intersect are considered good points at which to place the subject for an interesting composition. This is called the rule of thirds.

You can also crop this image by covering the top half (about 3/4" above her head), or crop the right-hand one-third of the image and create a long, tall photograph. The choice is yours. One last possible crop would be to combine the two above mentioned crops (at the top and on the right) to come in close around the young lady without much additional space around her.

○ SQUARE FORMAT

The flexibility in cropping is one of the reasons I use a square format camera. It allows me to make my cropping decision after I see the photograph. With rectangular format cameras, you have to make the decision as you take the photograph. I enjoy the versatility of square and, as you can see in this book, many of my images are presented square.

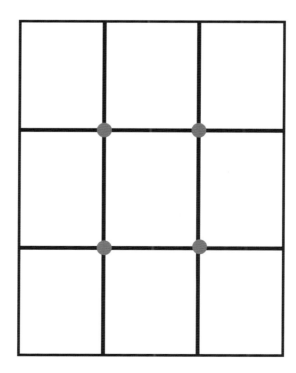

Divide the frame into thirds vertically and horizontally. The intersections of the dividing lines are strong locations for subject placement. This is called the ruled of thirds.

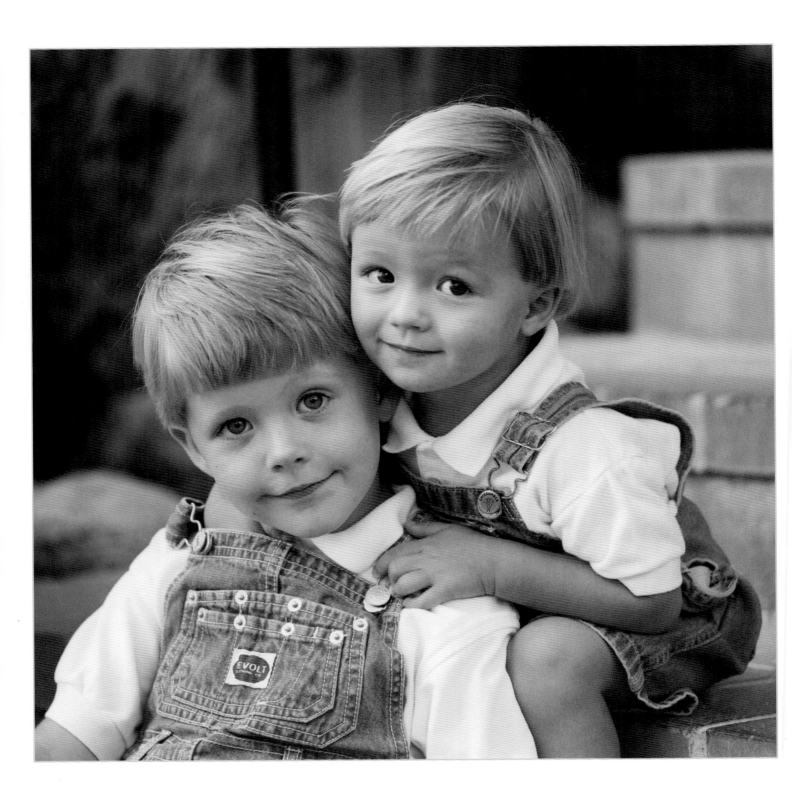

Working with Children

I used the natural levels of the steps to add interest to the pose. I placed the older brother on a lower step, and seated the younger brother on a higher one. This positioned their heads on different levels—but not too different. If I had posed the older (and taller) boy on the top step, their heads would have been too far apart. **With their heads and bodies close together, the pose shows the boys' closeness** and also conveys a sense of youthful innocence.

◎ CLOTHING

I love it when children dress alike. It takes your attention off the clothing and leaves it on the faces. Imagine if both of these boys were in two different colors—the first thing you would have seen is the clothing! These great faces deserve to be in the limelight.

◎ LIGHTING

This image was shot on a porch with a roof that blocked off the light from above, leaving the light from camera left as the main light source in the frame. This gives the light direction.

◎ PHOTOGRAPHY

I used a 250mm lens to create separation between the subject and the background (because of the shallow depth of field inherent with telephoto lenses). I also made the exposure wide open at F/5.6. and 1/60 second. To prevent camera movement and a blurry photograph, I mounted the camera on a tripod. Almost all of my portraits are made using a tripod to steady the camera. This also enables me to make eye contact with the subject(s) and to leave the camera to make minor adjustments with the subject and return to the camera in the proper position. This is especially important with children because, many times, an expression or pose may only last a moment. I want to be ready for that special instant.

◎ PSYCHOLOGY

With guidance from you, parents can be helped to better prepare their children for a productive session. When discussing the portrait session with small children, suggest that parents tell them that they are going to play with a nice man or woman. Overreacting tends to scare children, so they should make the session sound like it will be a fun adventure. Parents should not threaten children to "do good or else." If anything, suggest that they tell the kids that they will be rewarded for doing a good job. Never ask a child to say silly words such as "cheese"—these will produce only fake and forced expressions. Encourage moms and dads to relax and enjoy the session. Children can sense when parents are uptight or nervous, and they will begin to feel the same way.

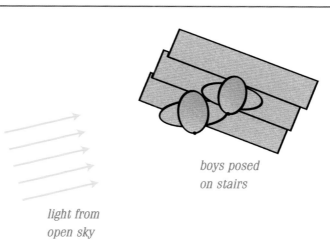

light from open sky

boys posed on stairs

I have found that sometimes small children generally do best when slightly contained. Many times a chair or, as in this case, a stroller helps keep the child from leaving the scene before the image can be taken. Children are also used to being in the apparatus, and therefore feel comfortable. **I had positioned this cute young girl so that no matter which way she looked, I would get a nice photograph.** I like the natural way she placed her hand on the front of the stroller. Something caught her attention and she turned her eyes to see what it was. It made for a cute photo.

○ BACKGROUND

I took the little girl outside to her front yard for the portrait. The bushes and grass, when thrown out of focus, make an abstract background. Using a long lens made the bright areas appear slightly larger, but less bright. That is one of the advantages of these lenses.

○ CROPPING

The photo is shown here full frame, but I would probably crop the photograph right at the top of her hat in order to remove the pole that is coming out the top of the head. This would also be a perfect situation for using a photo retouching program such as Adobe® Photoshop® to remove the pole and replace it with more bushes. It is amazing what computers and digital photography can do these days. With them, you can take a photo with a major

problem or distraction and make it much better.

○ PHOTOGRAPHY

Another great advantage of a telephoto lens is the fact that I can be 8–10 feet away and still create a fairly close-up photograph. This gives the child some space, so she is less aware of me taking her photograph. This makes her feel more at ease and behave more naturally.

○ LIGHTING

A house to the left of camera blocked much of the light, allowing light to come only from camera

right. This directional light shows the roundness of the girl's face and adds dimension to the image.

○ PSYCHOLOGY

A good portrait of a child can't be rushed. I try to reserve plenty of time for children's portrait sessions. Sometimes I may spend up to twenty minutes just greeting a child and building his or her trust before beginning the session. Sometimes it is best to have a parent or helper around while a child is being photographed, sometimes it is not. You will have to make that determination depending on the mood of the child.

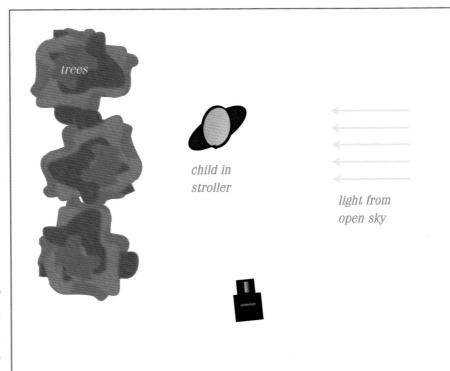

trees

child in stroller

light from open sky

Small Children

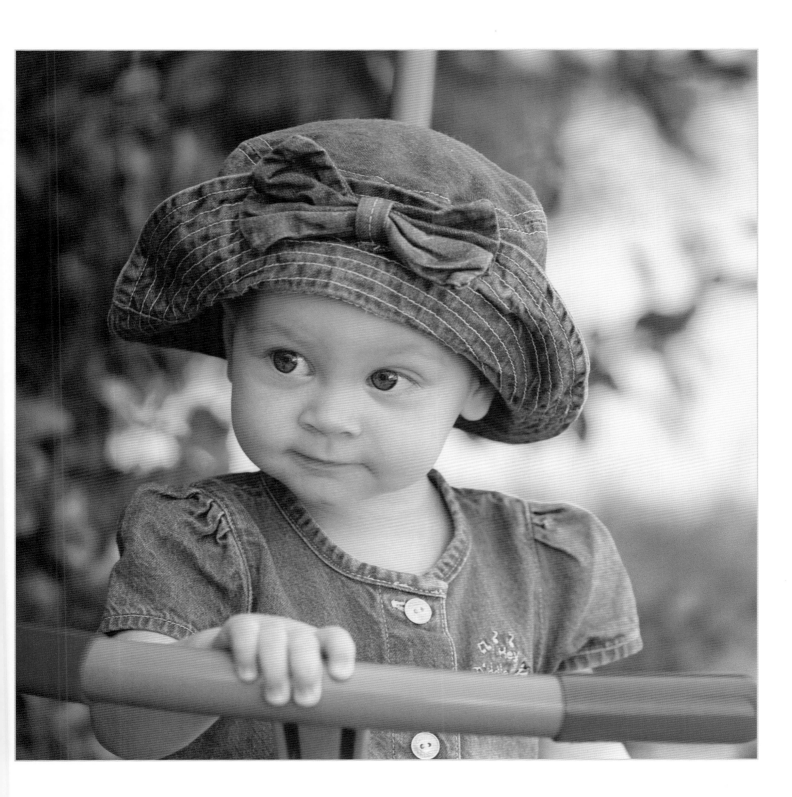

Natural Beauty

As you can see from this quiet image, simple posing can be both elegant and very beautiful. **I placed the two girls in the open gate area between two stone walls.** I had the older girl lean against the rock wall, placing her hands behind her in a fashion that seemed natural for her and added a sense of casualness to the photograph. Notice how her left foot was

brought slightly forward and bent in toward her body just a bit. This added detail makes the pose a bit more interesting. Her sister was posed standing close and holding a basket of flowers. I enjoy the way they are both looking down at the flowers in a natural and quiet way.

○ PROP

The girls' mom brought this basket to the session—an appropriate addition to this rustic image. She also brought these cute matching outfits. Their light pink color adds to the softness of the photograph. Shoes are often a problem on small children. The soles are ugly and they can sometimes dominate a portrait. Often, I prefer to remove the shoes. Here, the girls' little bare feet are very cute and innocent.

○ BACKGROUND

One of the most important elements in great photography is a nice background. The large rock walls contrast and balance nicely with the delicate plants, flowers and soft little girls. This portrait was taken at the Antique Rose Emporium in the Independence, Texas area. If you are ever in the area, stop by and visit—you will be pleasantly surprised!

○ PHOTOGRAPHY

Again, I used a 250mm telephoto lens. Can you tell it is my favorite? Without it, the background would have been too much in focus—and more of a distraction. It also allowed me to make the image without including the sky. Because of the narrow angle of coverage, the sky was not included above the tree line (except in the upper left-hand corner). I felt it would have been distracting to include it in the photograph.

○ PSYCHOLOGY

Children are soft and sensitive, and I feel that photographs of them should show this warmth. I typically take only a few portraits with big smiles. Instead, I love portraits like this that show the gentle side of children.

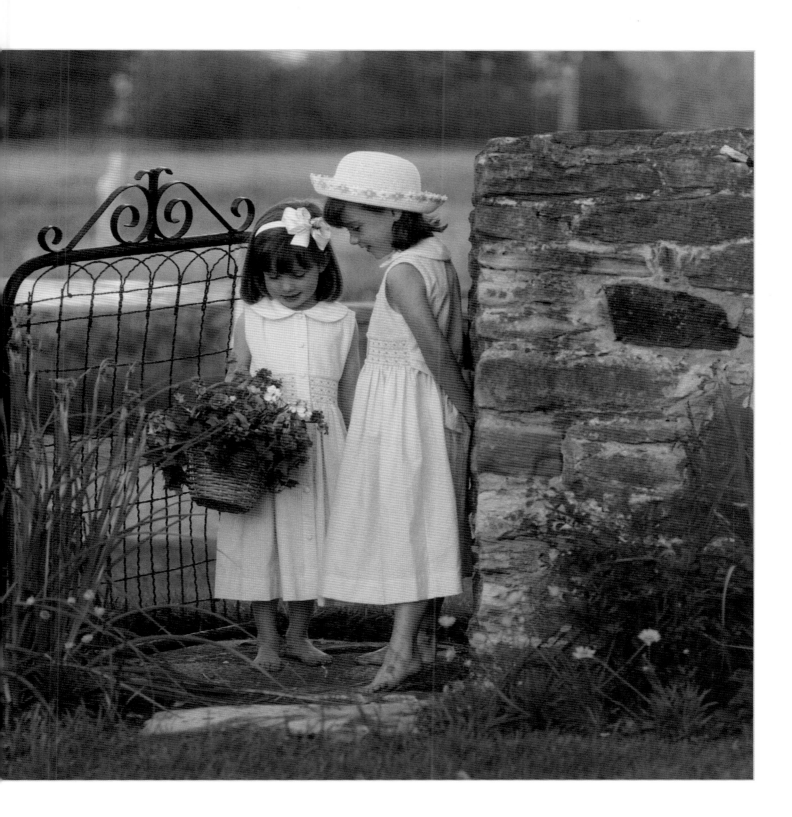

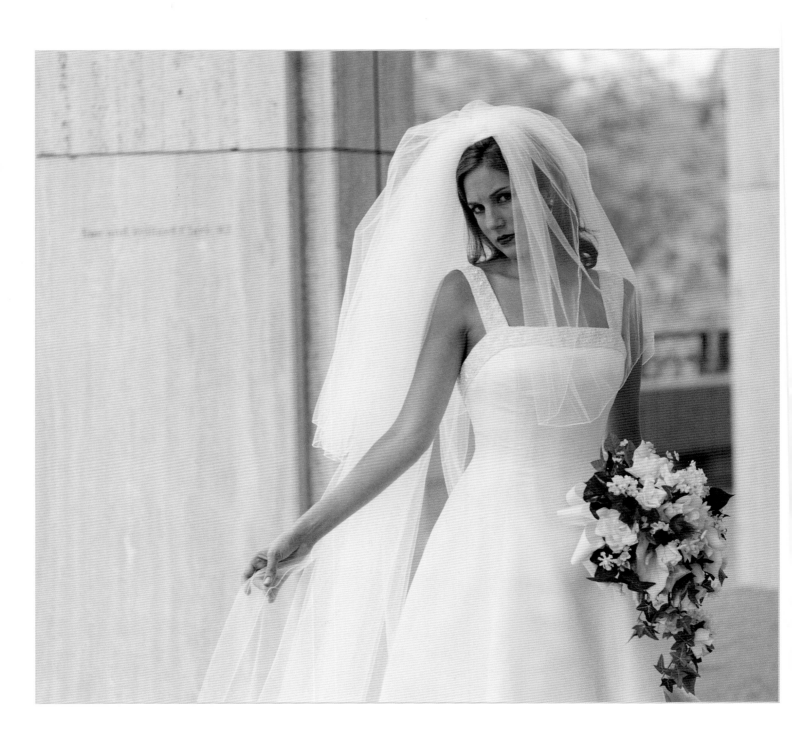

"C" Pose

I call this the "C" pose. I begin it by having the bride separate her feet to about shoulder width or a little wider. Then, I ask her to rock back and forth from side to side, ending with her weight on the foot away from the light source (her left foot in this case). The other foot (here, the right) is placed with only the toes and the inside ball of the foot touching the ground. This position for the lower body also tends to cause the subject to drop her shoulder on the same side of the body as the foot that her weight is on. Once this is accomplished, I have

her tilt her head toward her high shoulder, completing the "C" shape. In this case, it is a reversed "C" shape. To further accent the flow of the pose, **I had this bride grasp a small part of her veil and raise her right hand slightly.** Notice that she is using her thumb and middle finger to hold the veil very delicately. I find that more pleasing than using the thumb and first finger—especially when she lifts the index finger slightly.

○ PROP

The bouquet was an appropriate prop for this photograph. It is, of course, an element of the wedding accessories, but it also gave the bride something to do with her other hand. The bouquet adds the final leg to the triangular composition that includes the bouquet, her right hand, and her face. The bridal veil also functions as a prop—framing the bride's face. I also like the way the veil comes down close to the left side of her face, adding a little mystery to the image as she seems to almost peek out from behind it.

○ BACKGROUND

These columns are at the Clayton Williams Alumni Center at the Texas A&M campus in College Station, Texas. This is a favorite place for brides to have their por-

trait taken on campus. The straight lines of these columns seemed to balance with the lines of the dress and its simple but elegant style—with just a slight amount of bead work on the straps and trim of the gown. I try to choose backgrounds that don't detract from the subject but add to the overall feel of the portrait.

○ PHOTOGRAPHY

I have shown the entire frame below. In the final image (opposite) I cropped the photograph

about ¾" above the bride's head to remove the majority of the sky. I also cropped 1½" off the left side of the image to keep the sliver of background from showing on the edge of the image and causing a distraction. Cropping also allowed me to straighten the vertical lines.

○ LIGHTING

The photograph was taken on a large porch. The roof blocked off light from above, resulting in nice directional light from the open sky to the left of the camera.

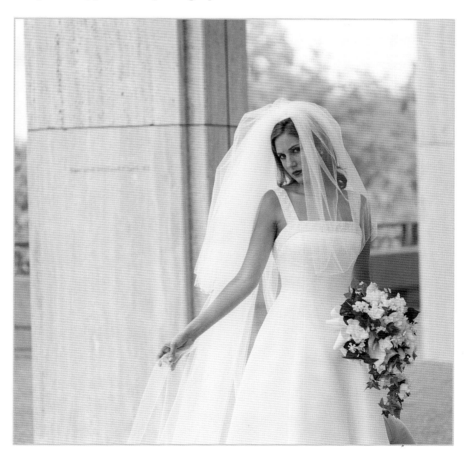

Setting Sun

After hiking and climbing all day, we reached the saddle (the area between the peaks) that we would use for our overnight rest before moving on to the top of "The Grand" the next day. Despite being exhausted, **we were overwhelmed by the beauty and the grandeur that the view from 12,000 feet offered us.** As the sun began to set through the thin clouds, its final rays offered a spectacular photographic opportunity. I didn't pose this subject (who also happens to be my best friend and climbing partner), he simply leaned back and comfortably crossed his hands and feet. As I've said, if you leave people alone many times they will pose themselves. I simply positioned the camera to capture a profile and some of the view.

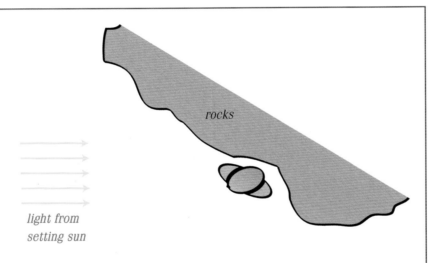

light from
setting sun

rocks

● BACKGROUND

The background is the Idaho side of the Grand Teton National Park. The next morning at about 3:30a.m. we began the last segment to the top—13,770 feet. In my opinion, this is one of the most beautiful parts of this country. To have a portrait of such a good friend, in a great place during a life-changing trip is special! Remember why we make photographs—to preserve memories. With natural light you can capture these spontaneous, fleeting moments as they happen.

◉ PHOTOGRAPHY

I waited to create this portrait until the sun was just about to go behind the horizon. At this point, the sun was low in contrast but still had a directional quality. I used the Nikon 8008s to make this photograph. Its matrix metering is very accurate in situations like this where you have several different contrast levels in the frame. I used a 35–70mm zoom set at the 35mm setting. This gave me an opportunity to show some of the scenery, without distorting the subject.

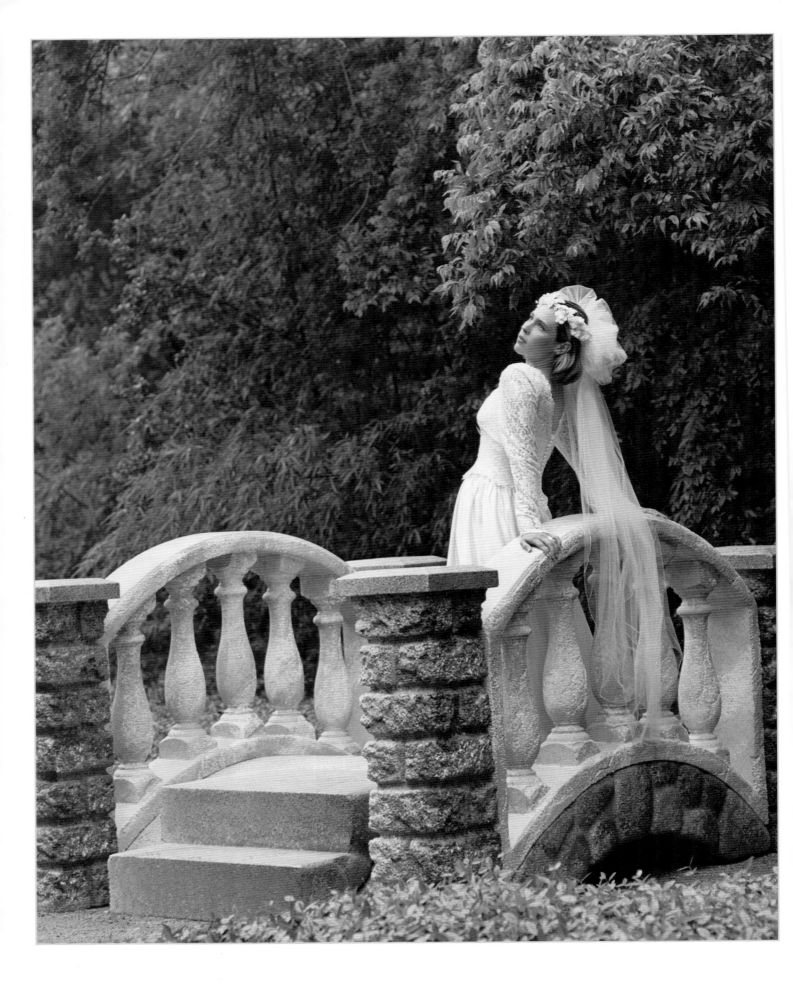

Head Tilt

While teaching at the Texas School of Professional Photography (www.ppa.com), I made this exposure of a bride on a bridge. To accent the slender figure of the young lady, I posed her in a "C" pose. **Here, you can see why this body position is called a "C" pose**—the curve runs through her entire body. Even her arms add to the flow of the pose. To soften the lines of the bridge, I allowed the veil to drape down over the rail.

○ PROP

The bridge is a prop manufactured by a Canadian scene design company called Off the Wall. It looks like a real stone and concrete bridge, but it is actually made of high density foam and covered with the same material that car bumpers are made of. It is then painted to look like stone and rock. It is an amazing prop, and portable enough that you can easily place it in the optimum position for both the subject and lighting.

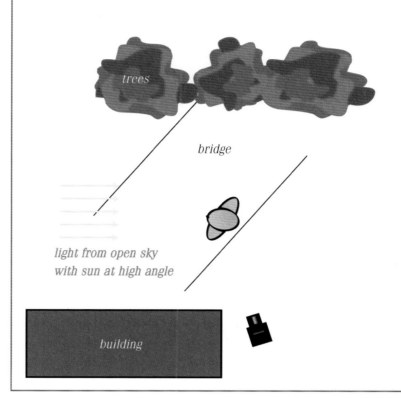

trees

bridge

light from open sky
with sun at high angle

building

○ PHOTOGRAPHY

In this portrait, the light was coming from above. If I had posed the bride looking straight forward, the light would have come from the top and caused dark shadows to form on her eyes. When photographing outdoor portraits, the light must strike the mask of the face (the area from the hairline to the chin). Since I couldn't move the light, to accomplish the proper effect I tilted the bride's head up toward the light source. This allowed the light to fully illuminate her face and open up the shadows.

Late Afternoon

A simple but elegant pose works perfectly for this bride. This typical standing pose begins with the feet, which become the base for the portrait. When you place the subject's weight on one foot (here the left), you'll naturally cause the same shoulder to drop slightly. **This combination adds flow and motion to the pose**, making it look natural—not stiff.

○ BACKGROUND

I am always on the lookout for great places to create natural light photography. This portrait was actually created on a golf course at a state park. I photographed the bride from across the small pond, which allowed me to include her reflection in the image. It's an interesting addition to the portrait, and one that I really like.

○ CROPPING

In addition to the way it is presented here, this image can be cropped into a long, thin photograph. Experiment with this image by placing pieces of paper across the top and bottom of it. Move them closer together and farther apart, notice how the dynamics and feeling of the image changes as the cropping changes.

○ COMPOSITION

One determining factor in composition is the size of the final image. Here, the bride is a rather small element in the frame. However, the photograph was going to be 24"x30". The size of

the subject is quite nice for an image of this larger size.

○ PHOTOGRAPHY

Because I made this image late in the afternoon, the light was very soft and low in contrast. Every-thing in the frame was illuminated equally. This keeps your attention on the bride. Because of the contrast of her white dress against the dark green foliage, she stands out very well from the environment around her.

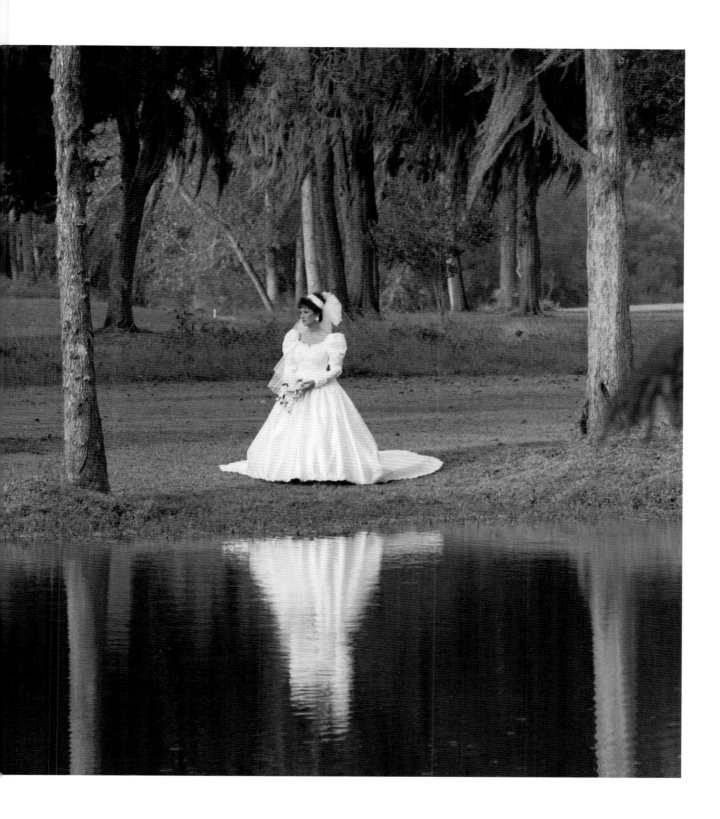

Glass Glare

This is a fun image of an older couple because it shows so much personality. When we first started thinking about doing the portrait of this couple, we considered a studio with suits and fancy clothes. But, the more I talked to them, the more I realized that wasn't compatible with their personalities. **They told me about their place in the country, so we decided that that would be a better place for doing the photographs.** A very important aspect of great portraiture is planning ahead of time. Determine what is important to your subjects—what is in their souls. Then try to capture their personalities in the photograph.

○ CLOTHING

Then we talked about clothing. Clothing is incredibly important in making portraits beautiful. The woman told me about a blue jean skirt that she had—of course, I figured he would have some jeans that would match well. We decided on white shirts to complete the outfits.

○ POSE

I started the pose with the gentleman. I opened the gate a little and just had him lean in a natural, comfortable pose. I made sure his left arm came straight across his body (rather than straight toward the camera, since this tends to foreshorten the arm). His right arm touched the gate in a very natural style. You will notice that his weight is shifted onto one foot; this dropped his right shoulder toward his wife. Look how comfortable his wife looks holding his arm.

○ GLASS GLARE

I found that having the couple look off camera accomplished several things. First, it made them look involved with the environment, and as through they are looking to the future. Second, it helped to eliminate glass glare, because of the way I have the faces turned. Glass glare (reflections of bright areas—often the sky) can be eliminated in several ways. Sometimes I have the subject borrow a pair of empty frames from their optometrist. The second method is to tilt the head or the glasses down. If the person is looking straight into the camera you can lift the back of the ear pieces up and eliminate the glare on the glass. Occasionally, you can turn the face one way or another to solve the problem. As it turned out, this method worked well for this situation—there is only a slight bit of glare on her glasses.

○ BACKGROUND

This is their place; it is very comfortable to them and means a lot. This fence surrounds the front yard. We took the image about 10:00 a.m., a time that can cause problems with hot spots on the background. I used a 120mm lens. A longer lens would have placed the fence more out of focus, but I wanted to make sure you could recognize it and the rock columns between the boards—even the tree. The 120mm lens recorded the background as slightly out of focus, but still recognizable and not distracting.

○ LIGHTING

The placement of the subjects in relationship to the light on their faces is very important. There was an area of open sky to the right of the camera. This created a short lighting pattern on the gentleman's face. If you draw a line vertically through the center of the face, from the forehead to the chin, with the face turned slightly away from the camera, one side is always smaller or "shorter." Short lighting means lighting this narrower side of the face. The woman's face is turned to what I call a modified profile. Not having a perfect profile works well because of her glasses—in a perfect profile the earpiece of her glasses would have covered her eye. Another thing I looked for was the light on the clothing—notice how it adds texture. There is also a bit of rim light (light coming from behind the subjects and adding separation). This came from the patch of sky that was behind and above the couple.

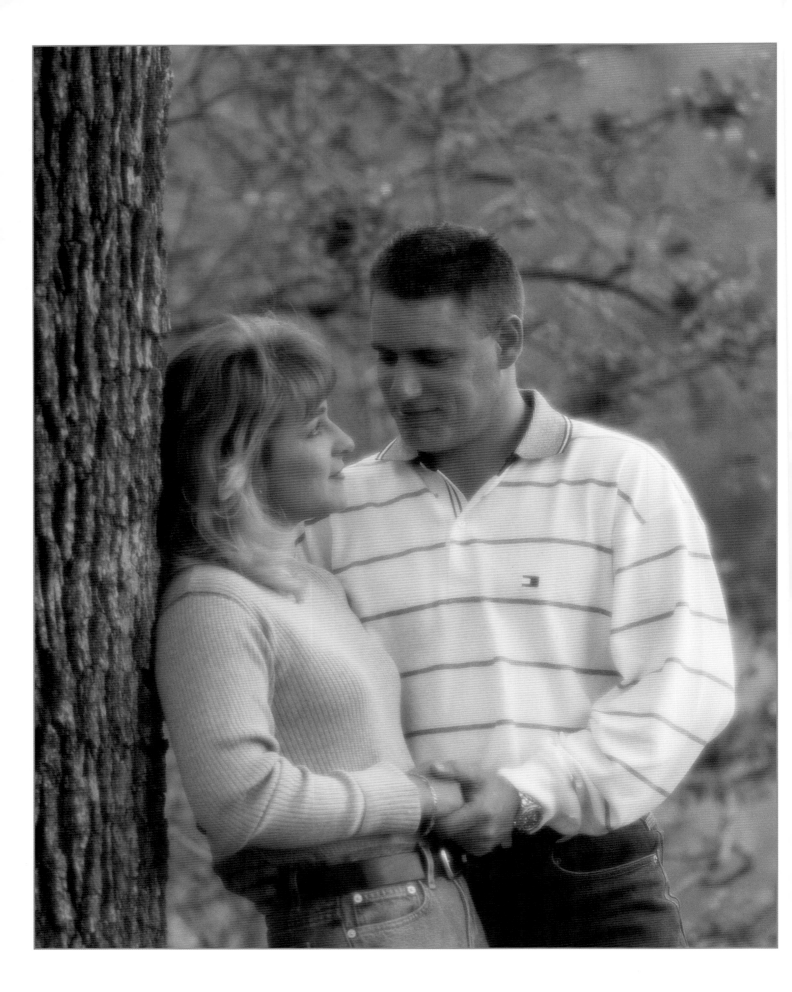

Leaning Pose

As you can tell, the pose in the photo on the facing page is very comfortable for this young couple. I started by leaning the woman against the tree. **When leaning a female subject against a tree or a building like this, I tell her not to let her bottom touch the tree.** She should arch her back so that only her shoulder touches. This tends to give the woman a slimmer appearance, and keeps the body in a more beautiful pose. You can see the result in photo B on the right.

For the portrait of the couple (opposite), I posed the woman, and then brought her fiancee to her. I placed his weight on the foot that was closest to her. This caused his shoulder to drop toward her. From this position you can do several images. The couple can look at the camera, they can look away from the camera at about a 45° angle, or they can look at each other. By photographing into the side of her body, I make sure I portray her in the most slender view. I also photograph almost full into the man, which tends to broaden him. If you have larger subjects, you would want to modify the poses a bit.

When photographing two people together, make sure each person looks good individually. In the photograph of the young lady alone (B) she is in the same pose as the couple together, except that her face is turned toward the camera. You'll notice that I also have her hands on her hips which creates nice lines through the shoulder. You will also notice the light crosses her face in an attractive way.

A

○ BACKGROUND

The background is an area on our 110-acre ranch. I chose this spot because this tree is on the edge of the woods. There is a large area of open sky all along one side, parallel to the camera. With such a large area of open sky, the light is soft and wraps around the subjects. Even if the young man had turned his face away from the light source, I would still have had enough light on his face for a good portrait. If this had been a smaller area of sky, the light would have been more contrasty and when he looked away from the light source, his face would have recorded darker.

○ PHOTOGRAPHY

I used a 250mm lens because there were a large number of small branches behind the couple. I wanted to make sure there was a soft, green abstract background—this also makes them stand out from the background. The most important thing in photographing outdoors is finding a good light source. You can see from the small photograph (A), that there is a large area of open sky parallel to the camera lens. Blue sky is our friend! If you have blue sky as the light source, you will have beautiful light on the face.

B

Composition

This portrait was created while we were waiting to do this young couple's engagement photos. **Almost anytime you have a window with indirect sunlight, you have a great opportunity for a window light photo.** I love the lines and the light, as it comes in from the left side of the photograph and crosses the brick wall.

○ PROPS

The glasses were appropriate props to add to the portrait, and also contributed to the posing. Placing the glasses on the table helped give the couple something to do with their hands, and to place their arms in a proper position. Sometimes very small props like this can contribute significantly to the storytelling quality of a portrait. This was a favorite bar the couple often visited after work, and when I saw it, I felt it could be a place for a beautiful photograph—even though it was not the original plan for the session. We later did photographs on the roof, showing in the background the places where they work and some other favorite buildings. Adding this indoor portrait provided a very different kind of photograph to include in their folio or collection of photographs. I really enjoy the painting, which lends a European flavor. The brick wall also adds great texture to the photograph.

○ LIGHTING

I used no reflectors and no lights—only the natural light that was coming in through the window. Having the couple turning their faces toward the light (instead of the camera) yielded beautifully illuminated faces. If they had been turned to face the camera, the effect would have been totally different—with one side of the face lit completely, and the other in full shadow (called split lighting).

○ COMPOSITION

I composed this image by placing the couple in the lower corner to give a sense of the intimacy of this special place. I also chose to include the window itself in order to balance with the couple's white shirts against the very dark table. Without the window, in fact, the left side of the photograph would be heavier and seem a little moodier. The artist gets to decide how he wants the photograph to look. I chose to leave the window in the photograph, in order to add a sense of lightness.

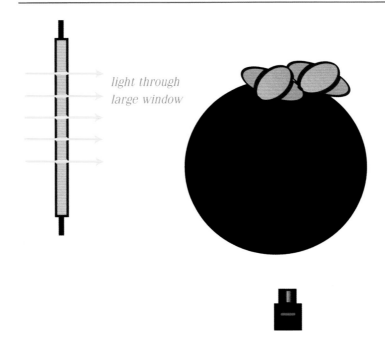

light through large window

Low Key

I began the pose by moving the young man toward the rock bridge and placed him in an area where his hand was comfortable on the rail of the bridge. I made sure his shoulder was not too high. **I placed the young lady so her head would be lower and complete the triangular composition** formed by her elbow and the two heads (opposite). This pose was versatile enough to permit several variations with only small adjustments. One variation is shown in the photograph below.

Notice, however, the small things that were done to make the larger photograph (opposite) look a little bit better. In the photo on the right, the woman's left hand *does* show off her engagement ring but it also looks like it comes out of nowhere over the man's left shoulder. This is distracting and draws your attention away from the faces. I also tilted their heads a bit closer together in the photo on the opposite page. I believe these two small adjustments make the photograph even nicer.

○ BACKGROUND

Because the couple wore dark green clothing, I decided to do this photograph in low key. Low key typically denotes a photo with a dark background that is paired with dark clothing (a high key image, in contrast, would feature a light or white background and matching clothing). The low key seems to carry the mood of the photograph and match the clothing very nicely.

○ LIGHTING

To accomplish the low key look I wanted, I chose a place where light was not striking the trees behind the couple, but did skim across their faces. I also made sure there was enough light from above to catch on the tops of their

shoulders and hair in order to create separation from the background. That keeps them from blending into the background. The skylight from above and to the left of the camera did this job nicely. Because the light had a good directional quality, it also did a nice job of shaping the couple's faces.

Posing Variations

These two portraits (opposite and below) demonstrate two similar poses used in a portrait session with a high school senior. In the image with his letter jacket (below), I had the young man lean forward into his arms while simply squatting down. This gives him a slightly more active and assertive look.

In the second photograph (opposite) he removed the jacket and I had him lean back onto the tree. It seemed to be a bit more of a comfortable look. I try to match the pose to the clothing.

○ PHOTOGRAPHY

One reason I chose this spot was because of the nice light. There was a building perpendicular to the background that blocked the light that was coming in from behind. Trees behind the camera also blocked some of the light from the front, leaving primarily the light from the left to illuminate his face. I find that **when you work on the edge of a treeline, you will generally get beautiful light** because the light comes only from the side. It is also important to find a place where you have some branches blocking the light from above, since these will make the eyes dark.

○ SEPARATION

In this particular place, there was a small patch of light behind the tree to the right of the photograph that illuminated the hair, creating separation between the subject and the dark background.

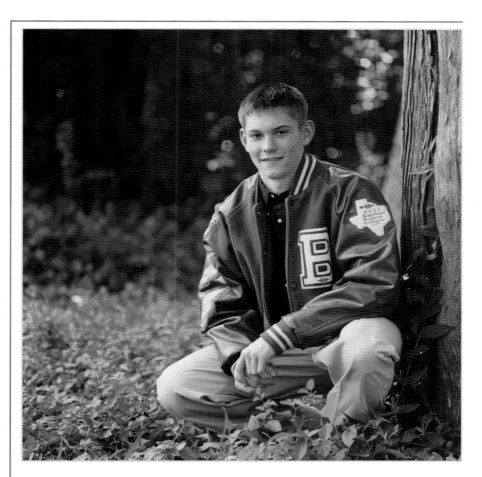

Match Background to Clothing

When photographing people, I look for backgrounds that match their clothing. In the photograph of the young lady with the white shirt (opposite), I chose a row of white columns. **This creates balance between the clothing and the background.** It's a high key look. In the photograph of her sitting on a curb (below), I chose a darker background to match her dark jacket.

In both instances, I also located a situation where we would be able to make use of light coming in from one side of the photograph.

The image against the white columns was taken on a porch. The light came in under the overhang from an area of open sky to the right of the photograph. In the other photograph, the trees created the exact same lighting situation as in the other image. In both instances, the light is blocked from the top. This allows light from the side (rather than above) to illuminate her face.

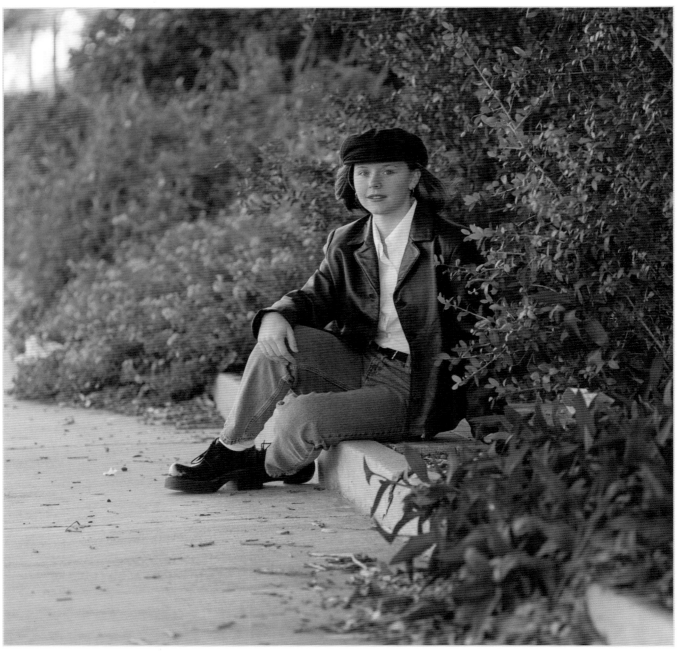

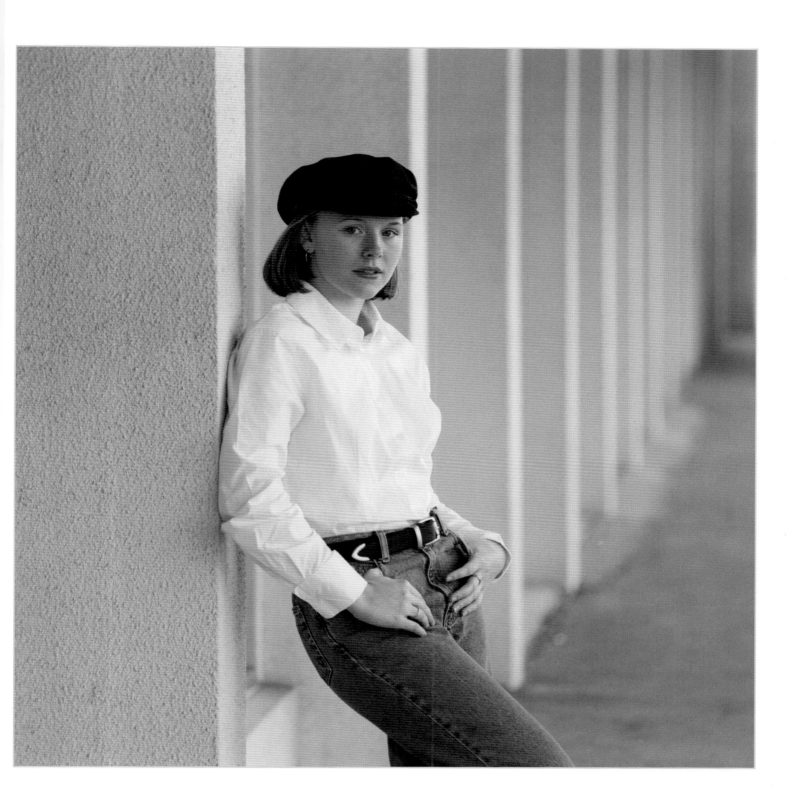

Cathedral Light

While studying art and photography in France, we went to this beautiful cathedral. I found this shaft of light coming through the window (top photograph). The overall illumination was quite low. The exposure in both this image and the one below was one second at F/5.6. **Using a tripod was crucial for holding the camera steady.** I also used a shutter release cable to eliminate any possible camera movement.

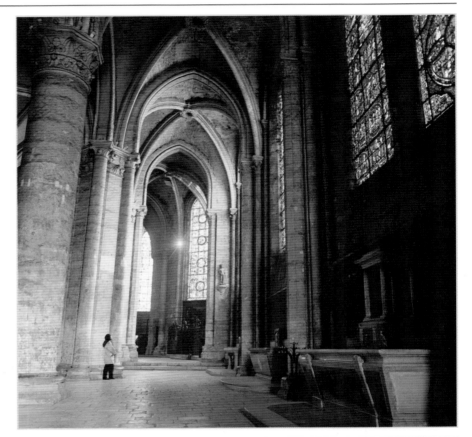

○ POLAROIDS

I took a meter reading but to check how the image would record on the film, I used a Polaroid back on my Hasselblad camera. The ability to use a Polaroid back is one of the reasons I like the Hasselblad camera so much. It allows me to create an instant preview with the same lens and exposure as I will use with the final image on film. Then I can study the Polaroid and adjust my exposure or posing accordingly. Using a Polaroid also allows you to check that everything is working properly on the camera.

○ LENS

I used a 50mm lens to show the height and architecture of the cathedral. In both images, I placed the subject very low in the corner of the frame and kept them small. This was to emphasize the grandeur of the setting.

Black and White

This pair of photographs was taken at a restaurant in France. The first (top) is a portrait of a father and son sitting at a window having lunch. They were members of the very delightful family that owned the restaurant where we were having lunch. They were very cooperative and posed for several portraits.

● LIGHTING AND POSING

Notice the beautiful light coming in from a window directly in front of the man (this window is out of frame). I like to let people be natural. In this case, they were cracking walnuts, drinking wine and enjoying their time together. Both images were created using only natural light (no reflectors), with a camera, light meter and tripod.

● BLACK AND WHITE

The black and white photograph of the young boy alone (bottom) was taken while he was sitting in the same position. **I moved in close in order to show the beautiful light on his face.** As you can see, the effect is just as beautiful.

Direction of Light

Here are two images of the same boy taken in the same spot. In the image on the left, the young man was posed with the sun behind him. I took my meter reading by using the flat disk on the Sekonic L-508 meter. **I placed the meter at the boy's face pointing straight back to the camera.** I used the flat disk setting on the light meter instead of the dome to keep the sun from hitting the dome. This could have given me an incorrect reading. The flat disk, on the other hand, measures only the light hitting the subject's face.

In the second photograph (right), I turned the young man around to face the opposite direction, and then took another meter reading. The scene is brighter because the sun was hitting the boy directly—giving us a totally different look at the same spot.

Whenever you are out shooting portraits, look around for different angles, different situations, and especially different lighting situations that will result in totally different photographs.

Window and Door Light

The portrait of this older gentleman in a tool shed (top) is another example of how you can make great images in a simple place. This image was done in the garage where they were pressing apples that day. I made the photograph while the man was simply standing around waiting for the next process. I used only my camera, a tripod and a light meter.

● DOOR LIGHTING

The light source for the portrait (the open doorway) was fairly large and soft. But, because there was not much reflective material in the garage, the overall light was somewhat contrasty. **In this particular case, I enjoy the contrast level.** It adds to the texture of his face.

● WINDOW LIGHTING

The bottom photo is another very simple image made only with a camera, tripod and meter. It goes to show, great portraiture doesn't necessarily require a lot of equipment—just a lot of careful observation and attention to detail. Here, the only light source is a window directly in front of the subject. He was seated, and placed in profile facing the window. The result is a very striking portrait.

Overcast Light

This image was taken on a fairly overcast day. However, if you notice the light on the faces, there was still some direction to the light, which came in from the right of the photograph. The reason the light has direction is there is a large building on the left and branches from the trees blocking the light from the top. This forces the light to come in from one side.

Sunny 16 Rule

I used the Sunny 16 rule to determine the exposure on this street scene. This rule states that, in bright sunlight, the correct exposure will be: F/16 with a shutter speed of one over the ISO. I was using 400 speed Kodak Portra NC. So, in this image, the Sunny 16 rule indicated an exposure of F/16 at 1/400 second. Since my camera doesn't have a 1/400 shutter speed, I had to use either 1/250 or 1/500. I chose to use 1/250 so as not to underexpose the image. From the basic setting at F/16, you can also calculate the correct equivalent exposure for shooting at any other aperture in the same light (for example, F/16 at 1/250 is equivalent to F/8 at 1/500).

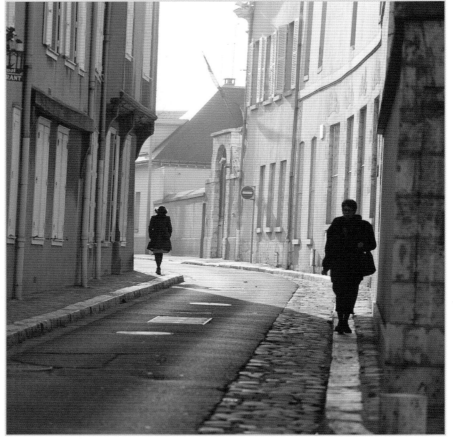

Street Scenes

These two street scenes were taken outside the restaurant where we photographed the young man and his father shown on page 95. In this situation, **the building behind the gentleman blocked the light coming from behind him.** His black hat blocked the light coming from above. This gives direction to the light.

○ POSING

Notice the natural poses he strikes in both the top and bottom photographs. Giving your subjects props to lean on, sit on or be involved with makes your images look comfortable and natural.

○ VACATION PHOTOS

When photographing on trips and vacations, try to include people in your images. As I look back over the thousands and thousands of vacation images I have made, the ones with people—either family or interesting people I met on the trip—are some of my favorites.

Two stops underexposed
(PVAC exposure #46)

One stop underexposed
(PVAC exposure #59)

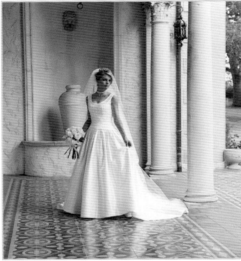

Proper exposure
(PVAC exposure #68)

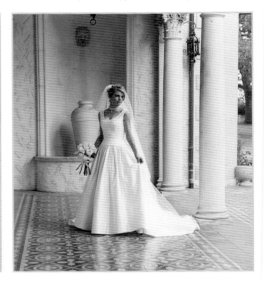

Film Test

As soon as the new Kodak Portra films came out I tested them. (You should always test new products and equipment before using them on clients.) In this test of Kodak Portra 400 NC, I did five photographs. The first exposure was intentionally two stops underexposed, the next image was one stop underexposed. The third photograph was taken at precisely the setting indicated by the meter. The next shot was one stop overexposed, and the final image was two stops overexposed. I sent the film off to be processed, and when I got it back they all

looked great. **Basically I had five saleable prints.** No other product that I am familiar with would have given me such a wide range of exposure latitude in the film. In fact, with any other film product, the photograph that was two stops underexposed would have had an overall milky gray or magenta cast that would have made it unusable. I don't recommend you overexpose or underexpose your film, but film with a good exposure latitude will save you if you do make a mistake.

The thing that totally convinced me that this is an incredible product was the final frame in this series—the exposure of the young lady on the steps. In this image, I was using an off-camera flash to supplement the ambient light. In

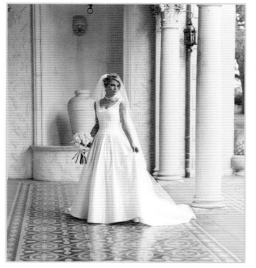

One stop overexposed
(PVAC exposure #85)

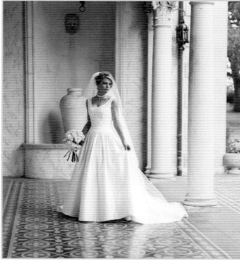

Two stops overexposed
(PVAC exposure #100)

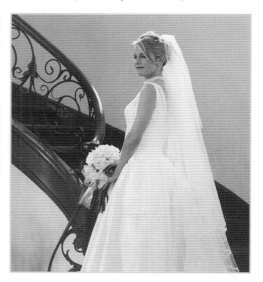

Four stops underexposed
(PVAC exposure #10)

this particular exposure, the flash did not fire. This image had a PVAC exposure number of 10, which is about 4 to 4½ stops underexposed.

I can't believe I got *any* image. That much underexposure with another film would have yielded a totally useless negative. You will see that, while it's not an awesome picture, it is certainly printable.

When I photograph weddings I regard this film as my emergency backup plan. If something unforeseen happens to the flash or camera on one or two of my exposures, I know this film will give me something that I can use.

Based on your own needs, you should **experiment with all the available products** to determine what works best. If you don't, you might miss out on a great product.

OPVAC
PVAC stands for Professional Video Analyzer Computer. It is a piece of equipment used to determine the exposure and color balance of negatives to be used by a machine printer.

Mother and Son

This handsome young man and his mom were models for my class at the California Photographic Workshop.

I think that the picture of the young man standing in the doorway (C) is especially enjoyable. It looks very natural—almost like you caught him as he opened the door. **The light coming through the doorway provided the only source of illumination.** His left hand on the doorknob and his right hand holding the coat over his shoulder gave him a natural and casual look. I also lowered the camera so that I would place his head in a spot in the frame where there would be separation between his hair and the dark area behind him. These little things are what you have to look for to make your images better than just average.

In the photograph of the boy and his mom (B), I found a nice window with non-direct sunlight coming in. She was posed nicely in the window seat. Her weight was on her left hip, which lowered her left shoulder. By turning her face toward the window I created a nice $\frac{2}{3}$ view of her face with good light in her eyes. I posed her son in a profile view, placing his face against the dark tones of her clothing to make his profile stand out.

The top photograph (A) was made in a stairway with light coming from above. While not technically perfect lighting, it does create a kind of moody image.

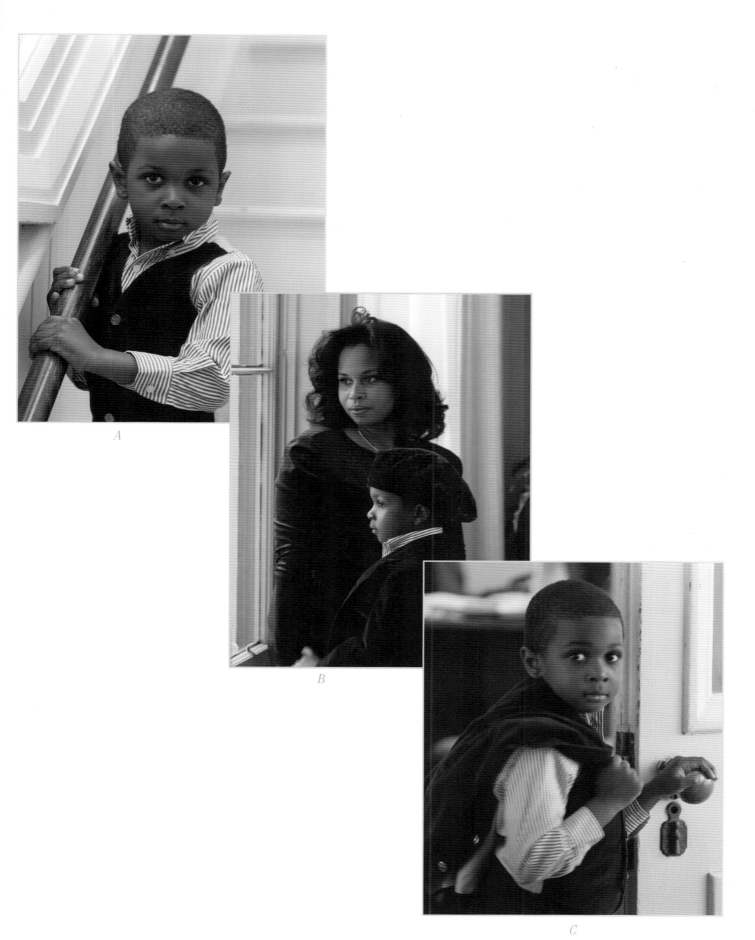

A

B

C

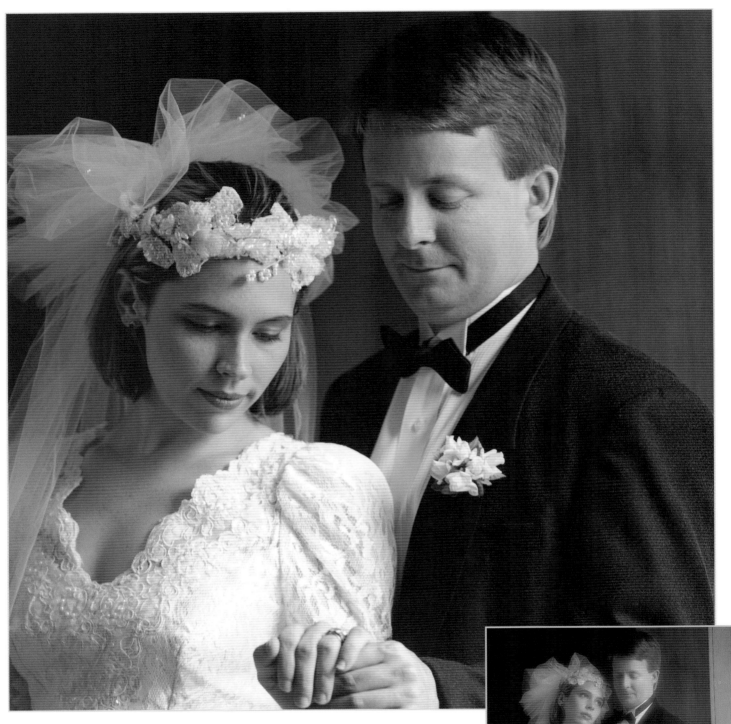

C (above)
D (right)

Wedding Portraits

This is a series of photographs to show you the variety that you can get with simply a doorway and natural light. In the first photograph (A), you can see what the entire area looked like around where the final series was made. Light was coming in from the stained glass windows and from the rather unattractive steel doorway. To use this photograph, I would crop out the top of the door where the closer shows and make a long slim line image. Or, **I might scan the image into a computer and use Photoshop® to digitally remove the door closer** and the handle—both of which are distractions.

⊙ ANGLE OF VIEW

The rest of the images were made by moving the camera very close to the wall and photographing the couple without the doorway showing. Photographs B, C and D show three very different images made within just a few seconds of each other. Each was shot in exactly the same place.

⊙ FILM SELECTION

The color images were made on Kodak Portra 400 NC, the brown-toned image (C) was made on Kodak T-Max CN. This film is processed and printed with color chemistry and color paper, but produces black and white or brown-toned photographs.

A (above)
B (left)

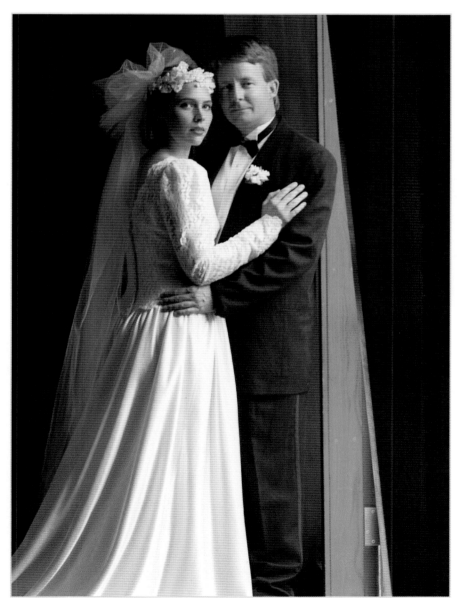

Two Backgrounds, One Spot

Both of these photographs were taken with the young lady sitting in exactly the same spot. **The only difference was where the camera was placed.** I created two very different images just by moving the camera left or right a few feet. She seems to stand out more with the tan colored rocks in the background. However, the photograph that includes the greenery and flowers gives her a somewhat lighter and happier feeling.

○ WORKING WITH CHILDREN

With older children, I talk to them as adults. I believe that if you reason with children they can understand your situation and are more cooperative. If you treat them like adults they will act like adults.

Soft Focus

By simply adding a soft focus filter, I was able to create two very different feelings in these bridal portraits.

◎ PHOTOGRAPHY

I placed the bride on the bridge and photographed her using a 250mm lens. I used this lens because, due to the pond, I had to photographer from over thirty feet away. However, I still wanted to keep her reasonably large in the image.

◎ FILTRATION

With the direct sunlight hitting her veil, I knew that the soft focus filter would produce a dreamy look. In fact, I find that if you use a soft focus filter on a very softly lit photograph, the image turns mushy. **The harder the light, the better soft focus filtration looks.** The filter I used is the Coral Soft from Lindahl Company. This filter combines soft focus with a warming filter.

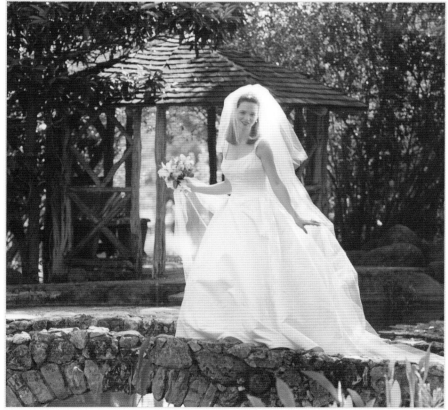

Special Days

Why do we create photographs? I believe it is to record memories and special events. Every year, I have photographed my two sons on their first day of school. Traditions like these can create a fun series of photographs that preserve those special events in your children's lives.

○ BACKGROUND

For this image, I quickly stepped outside the house and sat the two boys on a picnic table to create a differentiation in the heights of their heads.

○ LIGHTING

You can see that the sun is striking the back of the boys quite strongly. I could have used a large translucent light modifier to soften and spread out the sunlight. However, I was short on time and chose to just capture the image as it was. In this case, I feel it is just fine. It has a very natural look.

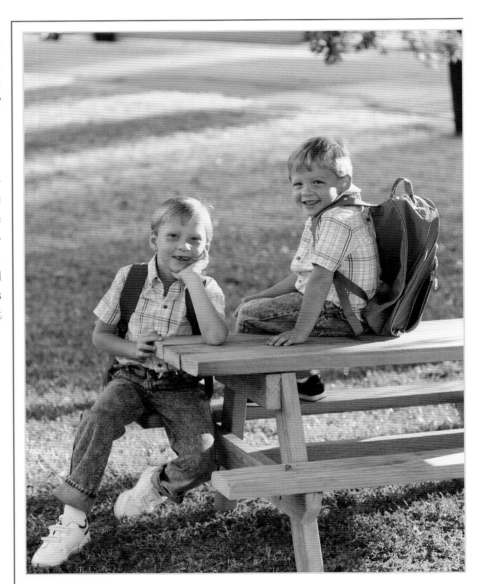

Careful Posing

As you can see from the image on the right, this is an attractive young lady. However, I want to show you that if you are not careful with your posing, **you can make a regular size person and look much larger than they actually are.** The two photographs below (A and B) were taken with-

in a few seconds of each other. You can see how a small turn of the body can add (A) or take away (B) pounds on the people you photograph. So, be aware of body positions, angles and lighting that can reduce or increase the apparent body size of your subject.

Typically, turning a body sideways helps to elongate limbs. You can also hide parts of bodies (using props or elements of the scene), and use lighting designed to keep problematic parts of the body in shadow. This will make your subjects look slimmer.

(Deb, thanks for letting me use *both* of these images to help make this point!)

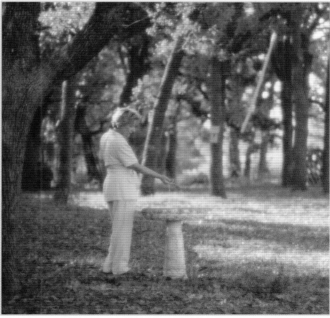

A

B

Urban Scenes

It's not just rustic settings that can produce beautiful natural light images—city scenes can also work very well. A rooftop in downtown Austin, Texas, was the location for this couple's portrait.

BACKGROUND

We began with portraits (below, A and B) against a brightly colored wall that I chose for its interesting graphic design. Our goal in the session was to shoot the rooftop images on the opposite page, so **we did these images while we were waiting for the sun to set.** I started with the gentleman, by having him lean against the wall and place his left foot up against it. Then, I simply brought the young lady to him, and he naturally put his arms around her. She gently rested her hand against his chest. The difference between the two images is the addition of a soft focus filter in photo B.

ADDITIONAL BACKGROUND

Once the sun had dropped, we created additional images of the couple sitting on the building top with the urban skyline in the background (opposite). Waiting for the sun to drop allowed us to work with soft, golden light from the open sky. Two different and distinct images are shown on the opposite page. In the smaller image, I directed the couple to look at each other. I placed them in the lower lefthand corner of the photograph and kept them small to reduce their size in relationship to the buildings in the background. In the larger photograph, I pulled in tighter on the couple for a closer, full-frame portrait

A

B

Adding Light, Changing Shutter Speed

In this series of photographs I combined natural light with electronic flash.

◎ NATURAL LIGHT ONLY

In the first image (A), natural light only was used. I took the meter reading at the subjects. The reading was 1/60 second at F/5.6. **While it is certainly a nice photograph, there is still some room for improvement.**

◎ ADDED FLASH

In the second image (B), I added a bare bulb flash with an output of F/5.6. This increased the light on their faces. When the lab prints the image for the proper exposure of the faces, the background goes a little darker.

A bare bulb flash is an electronic flash, such as the Lumedyne or Quantum Q, that has a removable reflector and a flash tube that extends out from the body of the flash. Here, the bare flash bulb was directed away from the camera, so that the body of the flash blocked its light from directly hitting the camera lens. Because the reflector was removed, light from the side of the protruding bulb illuminated the subjects.

◎ CHANGED SHUTTER SPEED

Flash illumination is controlled by the F-stop and background illumination is controlled by the shutter speed in relationship to the F-stop. For this reason, in the third photograph (C), I changed the shutter speed from 1/60 to 1/125. The F-stop on the camera was still at F/5.6, and the bare bulb flash was still set to give me F/5.6 on the subjects. However, because I changed the amount of light being recorded by the film from the background, the background is darker and the subjects stand out from it better.

◎ ARTISTIC CONTROL

You as the artist, get to decide on how much darker you want the background to be. I could have changed the F-stop again to darken the background even more. Once you know how to control the light, the choice is yours.

bare bulb flash
with removable reflector

A

B

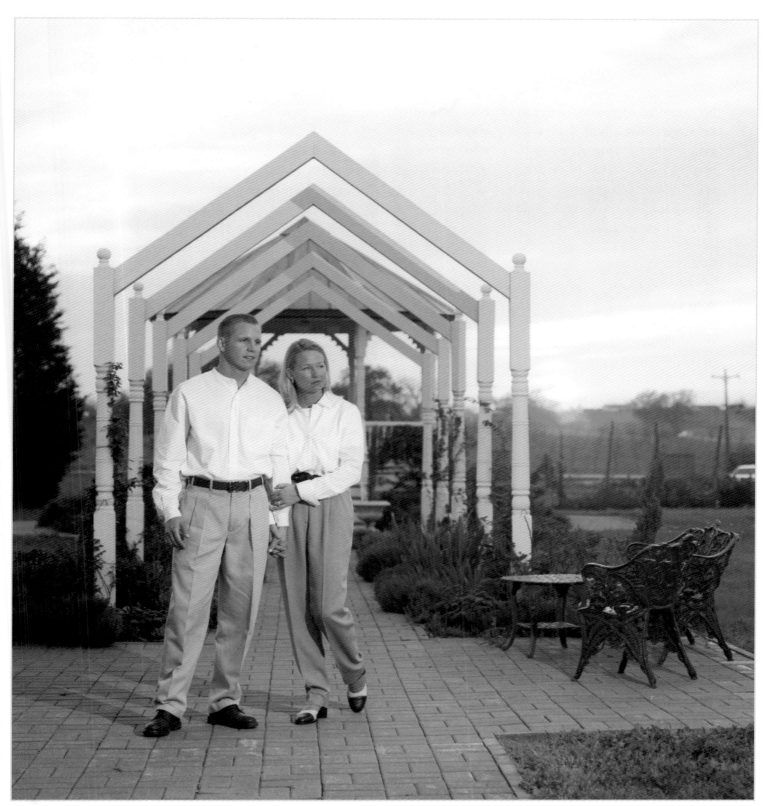

More on Adding Light

This is the same technique as was used with the engagement portrait on pages 112–113—except that, instead of using a bare bulb, I used an Eclipse light modifier and the Quantum Q flash. Just as in the other images, both flash units were set on manual. In photo A, natural light was used with no additional light. In photo B, I added the flash and increased the shutter speed. In photos C and D, I simply increased the shutter speed further.

This is a simple technique for adding flash to natural light portraits. **With it, you can totally control the lighting.**

A (natural light, 1/60 at F/5.6)

B (natural light plus flash at F/5.6 output, 1/125 at F/5.6)

C (natural light plus flash at F/5.6 output, 1/250 at F/5.6)

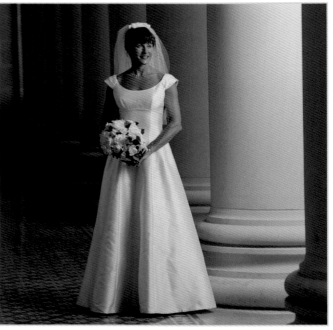

D (natural light plus flash at F/5/6 output, 1/500 at F/5.6)

Great Location, Bad Light

Here is a perfect example of finding a great location with not–so–great light. **Without added light, sometimes you cannot get a good image.**

○ PROBLEM

In the top photograph, I posed the young man at the top of a stairway at a parking garage. The angle of the handrail and the starkness of the concrete seemed to match the skateboarder's hair, attitude and prop. However, the light was coming from above, and it created dark shadows on his eyes and under his chin. Also, the background was very nondescript.

○ SOLUTION

In the second photograph (bottom), I added light from an off-camera Quantum Q flash. The original exposure was F/8 at 1/125 using Kodak 400 Portra VC film. The flash was set to give an exposure of F/11. I changed the camera setting to 1/500 at F/11. This caused the background to go darker. The flash gave proper illumination to the young man.

○ FLASH HEIGHT

The flash was also raised to eleven feet high to keep the light from coming from below. The young man was about nine feet up on the stairs. If I had left the flash set lower than he was, the lighting would have resembled stage lighting that is used for ghoulish characters.

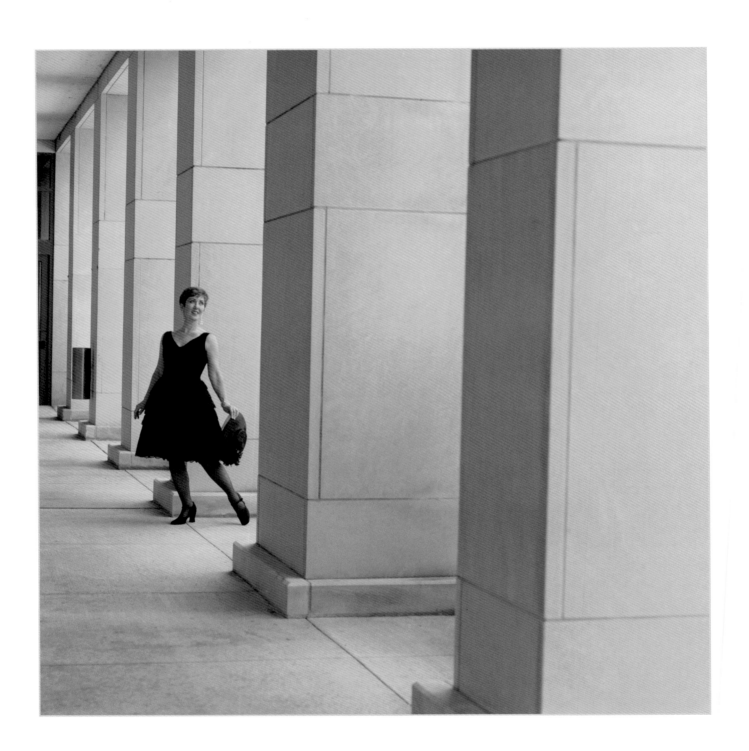

Conclusion

○ LOOKING FOR GREAT LIGHT

Keep your eyes open for light. The images on pages 116–118 were taken at the Mid America Institute of Professional Photography in Iowa (one of the many week-long, PPA-affiliated schools where I teach). These images are the result of simply keeping my eyes open for places that feature good directional light.

In the image with the columns (opposite), the light was coming in from the right of the camera. This is basica''y a porch lighting situation. The light was blocked from the left by the building, and from the top by the roof.

In the photographs on the stairs (right and next page), there was a small window just out of camera range on the left. Look at the exciting images I was able to create by looking for light. No additional light needed to be added for any of the portraits.

○ FILM SELECTION

All of these images are done on Kodak Portra 400 NC film. This film has a great grain structure. Using it, I have made enlargements as big as 30" x 40" with almost no visible grain.

The light from a small window (located just out of frame) was used to capture this portrait on a spiral staircase.

○ CRUCIAL ELEMENTS

What elements are common to most great photographs? I believe they are simplicity, composition, background and lighting.

Simplicity in a photograph can (ironically) be a rather complicated thing to accomplish. While a painter can just leave out clutter and distracting elements, a photographer must deal with them. We, as photographers, do have tools we can use to achieve simplicity. The camera is one tool that helps us simplify the things we see in the viewfinder. We can get physically closer to the subject, or use a longer lens (telephoto or zoom) to crop the image more tightly. The reason for keeping portraits simple is so you can better tell the story. Simplicity lets your eye find the subject more easily.

Composition is equally important. It gives the image a "feel." It can be a comfortable feel, a feel of tension, a relaxed feeling, or a feeling of realism. Careful composition also attracts the viewer's eyes to a photograph, and helps keep their attention on it longer.

The **background** is the canvas for the subject. It can add to or detract from the feeling of the image. Sometimes we want it simple, sometimes we need it more complex.

Finally, **lighting** is another very important factor. While natural light is only one of the types of light photographers work with, it's a very important one. As you've learned in this book, great lighting doesn't have to be complex or require expensive and complicated equipment. With careful use of natural light, you can create stunning portraits that are every bit as elegant and flattering as complex studio images.

Remember to look for opportunities to photograph at dawn, in the late afternoon, and at dusk—when the low angle of the sun produces rich, warm colors and long shadows. Avoid shooting at noon, a time when light is very "flat." Also, avoid situations where overhead light causes dark shadows under your subject's eyes (or turn the subject's face up toward the light source to open up those shadows). When necessary, you can also use simple flash techniques to augment natural light.

With careful attention, and some practice, natural light is sure to become one of your favorite tools for portrait photography.

Always be on the lookout for excellent directional lighting. It is the key to creating outstanding natural light portraits.

Resources

● PROFESSIONAL PHOTOGRAPHIC ORGANIZATIONS

Professional Photographers of America
229 Peachtree St NE Ste 2200,
International Tower
Atlanta, GA 30303
(404) 522-8600
www.ppa.com

Wedding and Portrait Photographers International
PO Box 2003
Santa Monica, CA 90406
www.wppi-online.com

● CAMERAS

Hasselblad
10 Madison Rd.
Fairfield, NJ 07004
(973) 227-7320
www.hasselblad.se

Nikon
1300 Walt Whitman Rd.
Melville, NY 11747
www.nikon.com

● TRIPOD

Bogen
Bogen Photo Corp.
565 E. Cresent Ave.
Ramsey, NJ 07446
www.manfrotto.it:80/bogen/

● PHOTO EDUCATION

Simply Selling Business Audio Tape Series
PO Box 1120
Caldwell, TX 77836
Fax (979)272-5201
www.simplyselling.com

Photo Vision—A Video Magazine
15513 Summer Grove Court
North Potomac, MD 20878
Fax (301)977-2676
(888)880-1441
www.photovisionvideo.com

Week Long Schools
(as mentioned in text)
Professional Photographers of America (PPA)
(404) 522-8600
www.ppa.com

● LIGHTING EQUIPMENT

Quantum
1075 Stewart Ave.
Garden City, NY 11530
(516) 222-6000
www.qtm.com

Visatec Lights
10 Madison Rd.
Fairfield, NJ 07004
(973) 227-7320
www.hasselblad.se

● MODULAR BELT AND CASE SYSTEM

Kinesis Photo Gear
5875 Simms St
Arvada, CO 80004
(435)462-2266
www.kinesisgear.com

● PROPS

American Photographic Resources
Randy and Patty Dunham
PO Box 820127
Ft. Worth, TX 76182
(817) 431-0434

Off the Wall Productions
493 Henderson Dr
Regina, SK S4N 5X1
Canada
www.offwallprod.com

● FILM

Eastman Kodak
www.kodak.com

For information on Doug Box's current speaking/workshop schedule, contact:
Douglas Allen Box—Master Photographer
dougbox@aol.com e-mail
www.dougbox.com
www.simplyselling.com

Index

PROFESSIONAL MODEL PORTFOLIOS
A STEP-BY-STEP GUIDE FOR PHOTOGRAPHERS

Billy Pegram

Learn to create portfolios that will get your clients noticed—and hired! $34.95 list, 8.5x11, 128p, 100 color images, index, order no. 1789.

THE PORTRAIT PHOTOGRAPHER'S GUIDE TO POSING

Bill Hurter

Posing can make or break an image. Now you can get the posing tips and techniques that have propelled the finest portrait photographers in the industry to the top. $34.95 list, 8.5x11, 128p, 200 color photos, index, order no. 1779.

MASTER LIGHTING GUIDE
FOR PORTRAIT PHOTOGRAPHERS

Christopher Grey

Efficiently light executive and model portraits, high and low key images, and more. Master traditional lighting styles and use creative modifications that will maximize your results. $29.95 list, 8.5x11, 128p, 300 color photos, index, order no. 1778.

STUDIO LIGHTING
A PRIMER FOR PHOTOGRAPHERS

Lou Jacobs Jr.

Get started in studio lighting. Jacobs outlines equipment needs, terminology, lighting setups and much more, showing you how to create top-notch portraits and still lifes. $29.95 list, 8.5x11, 128p, 190 color photos index, order no. 1787.

LIGHTING TECHNIQUES FOR FASHION AND GLAMOUR PHOTOGRAPHY

Stephen A. Dantzig, PsyD.

In fashion and glamour photography, light is the key to producing images with impact. With these techniques, you'll be primed for success! $29.95 list, 8.5x11, 128p, over 200 color images, index, order no. 1795.

WEDDING AND PORTRAIT PHOTOGRAPHERS' LEGAL HANDBOOK

N. Phillips and C. Nudo, Esq.

Don't leave yourself exposed! Sample forms and practical discussions help you protect yourself and your business. $29.95 list, 8.5x11, 128p, 25 sample forms, index, order no. 1796.

THE BEST OF PHOTOGRAPHIC LIGHTING

Bill Hurter

Top professionals reveal the secrets behind their successful strategies for studio, location, and outdoor lighting. Packed with tips for portraits, still lifes, and more. $34.95 list, 8.5x11, 128p, 150 color photos, index, order no. 1808.

MARKETING & SELLING TECHNIQUES
FOR DIGITAL PORTRAIT PHOTOGRAPHY

Kathleen Hawkins

Great portraits aren't enough to ensure the success of your business! Learn how to attract clients and boost your sales. $34.95 list, 8.5x11, 128p, 150 color photos, index, order no. 1804.

DIGITAL PHOTOGRAPHY BOOT CAMP

Kevin Kubota

Kevin Kubota's popular workshop is now a book! A down-and-dirty, step-by-step course in building a professional photography workflow and creating digital images that sell! $34.95 list, 8.5x11, 128p, 250 color images, index, order no. 1809.

PROFESSIONAL POSING TECHNIQUES FOR WEDDING AND PORTRAIT PHOTOGRAPHERS

Norman Phillips

Master the techniques you need to pose subjects successfully—whether you are working with men, women, children, or groups. $34.95 list, 8.5x11, 128p, 260 color photos, index, order no. 1810.

THE BEST OF FAMILY PORTRAIT PHOTOGRAPHY

Bill Hurter

Acclaimed photographers reveal the secrets behind their most successful family portraits. Packed with award-winning images and helpful techniques. $34.95 list, 8.5x11, 128p, 150 color photos, index, order no. 1812.

MASTER COMPOSITION GUIDE FOR DIGITAL PHOTOGRAPHERS

Ernst Wildi

Composition can truly make or break an image. Master photographer Ernst Wildi shows you how to analyze your scene or subject and produce the best-possible image. $34.95 list, 8.5x11, 128p, 150 color photos, index, order no. 1817.

THE BEST OF ADOBE® PHOTOSHOP®

Bill Hurter

Rangefinder editor Bill Hurter calls on the industry's top photographers to share their strategies for using Photoshop to intensify and sculpt their images. $34.95 list, 8.5x11, 128p, 170 color photos, 10 screen shots, index, order no. 1818.

MASTER LIGHTING TECHNIQUES

FOR OUTDOOR AND LOCATION DIGITAL PORTRAIT PHOTOGRAPHY

Stephen A. Dantzig

Use natural light alone or with flash fill, barebulb, and strobes to shoot perfect portraits all day long. $34.95 list, 8.5x11, 128p, 175 color photos, diagrams, index, order no. 1821.

BEGINNER'S GUIDE TO ADOBE® PHOTOSHOP®, 3rd Ed.

Michelle Perkins

Enhance your photos or add unique effects to any image. Short, easy-to-digest lessons will boost your confidence and ensure outstanding images. $34.95 list, 8.5x11, 128p, 80 color images, 120 screen shots, order no. 1823.

THE BEST OF PROFESSIONAL DIGITAL PHOTOGRAPHY

Bill Hurter

Digital imaging has a stronghold on photography. This book spotlights the methods that today's photographers use to create their best images. $34.95 list, 8.5x11, 128p, 180 color photos, 20 screen shots, index, order no. 1824.

PROFESSIONAL PORTRAIT LIGHTING

TECHNIQUES AND IMAGES FROM MASTER PHOTOGRAPHERS

Michelle Perkins

Get a behind-the-scenes look at the lighting techniques employed by the world's top portrait photographers. $34.95 list, 8.5x11, 128p, 200 color photos, index, order no. 2000.

MASTER POSING GUIDE

FOR CHILDREN'S PORTRAIT PHOTOGRAPHY

Norman Phillips

Create perfect portraits of infants, tots, kids, and teens. Includes techniques for standing, sitting, and floor poses for boys and girls, individuals, and groups. $34.95 list, 8.5x11, 128p, 305 color images, order no. 1826.

WEDDING PHOTOGRAPHER'S HANDBOOK

Bill Hurter

Learn to produce images with technical proficiency and superb, unbridled artistry. Includes images and insights from top industry pros. $34.95 list, 8.5x11, 128p, 180 color photos, 10 screen shots, index, order no. 1827.

RANGEFINDER'S PROFESSIONAL PHOTOGRAPHY

edited by Bill Hurter

Editor Bill Hurter shares over one hundred "recipes" from *Rangefinder's* popular cookbook series, showing you how to shoot, pose, light, and edit fabulous images. $34.95 list, 8.5x11, 128p, 150 color photos, index, order no. 1828.

LEGAL HANDBOOK FOR PHOTOGRAPHERS, 2nd Ed.

Bert P. Krages, Esq.

Learn what you can and cannot photograph, how to handle conflicts should they arise, how to protect your rights to your images in the digital age, and more. $34.95 list, 8.5x11, 128p, 80 b&w photos, index, order no. 1829.

MASTER GUIDE

FOR PROFESSIONAL PHOTOGRAPHERS

Patrick Rice

Turn your hobby into a thriving profession. This book covers equipment essentials, capture strategies, lighting, posing, digital effects, and more, providing a solid footing for a successful career. $34.95 list, 8.5x11, 128p, 200 color images, order no. 1830.

PROFESSIONAL FILTER TECHNIQUES

FOR DIGITAL PHOTOGRAPHERS

Stan Sholik

Select the best filter options for your photographic style and discover how their use will affect your images. $34.95 list, 8.5x11, 128p, 150 color images, index, order no. 1831.

MASTER'S GUIDE TO WEDDING PHOTOGRAPHY

CAPTURING UNFORGETTABLE MOMENTS AND LASTING IMPRESSIONS

Marcus Bell

Learn to capture the unique energy and mood of each wedding and build a lifelong client relationship. $34.95 list, 8.5x11, 128p, 200 color photos, index, order no. 1832.

MASTER LIGHTING GUIDE
FOR COMMERCIAL PHOTOGRAPHERS

Robert Morrissey

Use the tools and techniques pros rely on to land corporate clients. Includes diagrams, images, and techniques for a failsafe approach for shots that sell. $34.95 list, 8.5x11, 128p, 110 color photos, 125 diagrams, index, order no. 1833.

DIGITAL CAPTURE AND WORKFLOW
FOR PROFESSIONAL PHOTOGRAPHERS

Tom Lee

Cut your image-processing time by fine-tuning your workflow. Includes tips for working with Photoshop and Adobe Bridge, plus framing, matting, and more. $34.95 list, 8.5x11, 128p, 150 color images, index, order no. 1835.

THE PHOTOGRAPHER'S GUIDE TO COLOR MANAGEMENT
PROFESSIONAL TECHNIQUES FOR CONSISTENT RESULTS

Phil Nelson

Learn how to keep color consistent from device to device, ensuring greater efficiency and more accurate results. $34.95 list, 8.5x11, 128p, 175 color photos, index, order no. 1838.

SOFTBOX LIGHTING TECHNIQUES
FOR PROFESSIONAL PHOTOGRAPHERS

Stephen A. Dantzig

Learn to use one of photography's most popular lighting devices to produce soft and flawless effects for portraits, product shots, and more. $34.95 list, 8.5x11, 128p, 260 color images, index, order no. 1839.

CHILDREN'S PORTRAIT PHOTOGRAPHY HANDBOOK

Bill Hurter

Packed with inside tips from industry leaders, this book shows you the ins and outs of working with some of photography's most challenging subjects. $34.95 list, 8.5x11, 128p, 175 color images, index, order no. 1840.

JEFF SMITH'S LIGHTING FOR OUTDOOR AND LOCATION PORTRAIT PHOTOGRAPHY

Learn how to use light throughout the day—indoors and out—and make location portraits a highly profitable venture for your studio. $34.95 list, 8.5x11, 128p, 170 color images, index, order no. 1841.

PROFESSIONAL CHILDREN'S PORTRAIT PHOTOGRAPHY

Lou Jacobs Jr.

Fifteen top photographers reveal their most successful techniques—from working with unccoperative kids, to lighting, to marketing your studio. $34.95 list, 8.5x11, 128p, 200 color images, index, order no. 2001.

CHILDREN'S PORTRAIT PHOTOGRAPHY
A PHOTOJOURNALISTIC APPROACH

Kevin Newsome

Learn how to capture spirited images that reflect your young subject's unique personality and developmental stage. $34.95 list, 8.5x11, 128p, 150 color images, index, order no. 1843.

PROFESSIONAL PORTRAIT POSING
TECHNIQUES AND IMAGES FROM MASTER PHOTOGRAPHERS

Michelle Perkins

Learn how master photographers pose subjects to create unforgettable images. $34.95 list, 8.5x11, 128p, 175 color images, index, order no. 2002.